Instant
OIL PAINTING

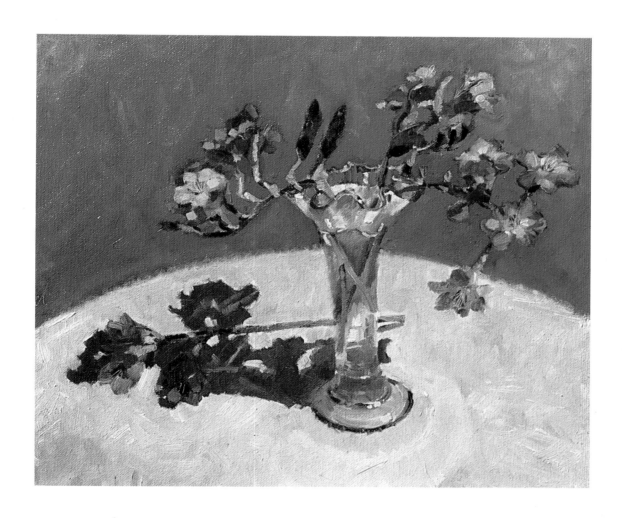

This book is dedicated to my nephew and niece, Antony and Helen. My brother is lucky to have such children.

Also to Sue Day, who has given me the time to do all I ever wanted to do.

Instant
OIL PAINTING

Quick techniques to create great pictures

Noel Gregory

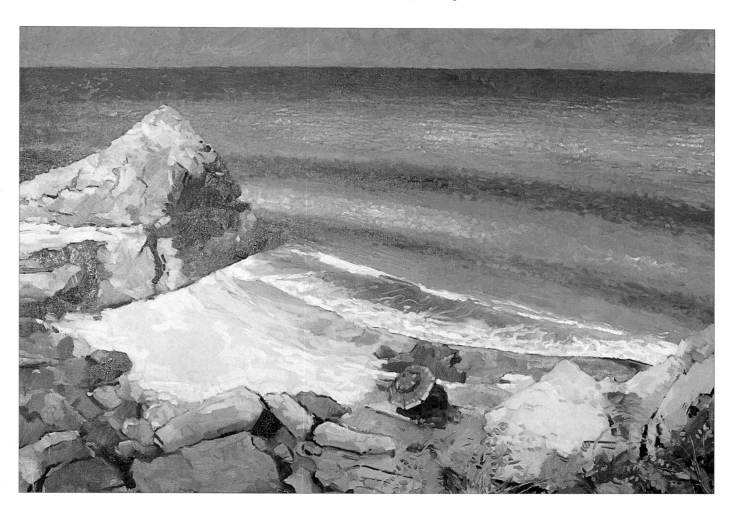

SEARCH PRESS

First published in Great Britain 2006

Search Press Limited
Wellwood, North Farm Road,
Tunbridge Wells, Kent TN2 3DR

Text copyright © Noel Gregory 2006

Photographs by Charlotte de la Bédoyère, Search Press Studios

Product photographs on pages 8–13 supplied by Winsor & Newton

Photographs and design copyright © Search Press Ltd. 2006

ISBN 978-1-84448-039-5

The Publishers and author can accept no responsibility for any consequences arising from the information, advice or instructions given in this publication.

The publishers would like to thank Winsor & Newton for supplying the materials used in this book.

Suppliers
If you have difficulty in obtaining any of the materials and equipment mentioned in this book, please visit the Search Press website for details of suppliers: www.searchpress.com

Winsor & Newton, UK Marketing
Whitefriars Avenue, Harrow, Middlesex, HA3 5RH

Publishers' note

All the step-by-step photographs in this book feature the author, Noel Gregory, demonstrating his painting techniques. No models have been used.

There are references to animal hair brushes in this book. It is the Publisher's custom to recommend synthetic materials as substitutes for animal products wherever possible. There is now a large range of brushes available made from artificial fibres, and they are satisfactory substitutes for those made from natural fibres.

Manufactured by Classicscan Pte Ltd, Singapore

Printed in Malaysia by Times Offset (M) Sdn Bhd

Acknowledgements

To an old friend Tony 'Popa' Messum, who has sadly left us; and whose passing leaves a gap that will be impossible to fill. His encouragement and humour was second to none. I will miss him greatly.

Cover:
Geranium Wall
500 x 600mm (20 x 23½in)

3½ Hours

This picture of the village where I live in southern Spain is a good example of painting quickly. The simple composition of a stone wall, vibrant flowers and sunwashed houses against a blue sky, is made more exciting by the exclusion of detail.

Page 1:
Fuchsias in a Glass Vase
410 x 330mm (16 x 13in)

3 Hours

A classic still life of flowers.

Page 3:
Parasol on a Beach
1000 x 730mm (40 x 29in)

5 Hours

A simple shape in a landscape can dramatically enhance a picture, as in this painting of a secluded beach. A solitary red parasol offers a wonderful focal point, drawing the eye down past the rocks on to the sand. The colour red has great impact when used in this way and no other colour would have worked nearly as well here.

Opposite:
Almond Blossom, Almeria, Southern Spain
450 x 330mm (18 x 13in)

2½ Hours

A good example of creating blossom quickly using a cloth containing turpentine (see pages 40–41).

CONTENTS

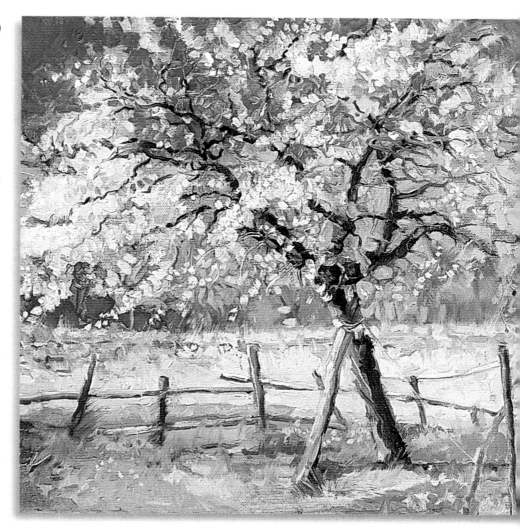

INTRODUCTION

It is possible to produce immediate results with oil paints. Quick methods can be exciting and challenging, and with practice you will soon be able to master a range of techniques that will enable you to build up beautiful paintings of which you can be proud. The delight of working in a spontaneous and intuitive way is achievable whatever your skill level, and it is also highly enjoyable. Imagine the pleasure of capturing the freshness of an early morning seascape, the splendour of a dramatic mountain scene, or the peacefulness of a sun-drenched landscape. What could be better than to re-create the magic and beauty of the world around you?

In this book I show you how to paint in a spontaneous way. I have used the word *instant* in the title, but really only a photograph could be called so. Photographs, however, do not always capture the intensity of light, the subtlety of tone, the shadows, depth or texture. A painting can portray all these things and more. 'Instant' in oil painting terms means being taught how to master quick techniques, how to develop skills and build up confidence, and how to maximise the effects of simple brush strokes.

To help you understand the basics, the book has been divided into a series of steps, or lessons, leading you through simple stages on to more challenging projects. None of them is difficult and they offer instant rewards. In a short time you will discover that painting is indeed fun, and the more fun you have, the more you will like to practice. You will discover all sorts of secrets and tricks that go towards making great paintings.

Whether your style is realistic or loose, you will soon be experiencing the rich pleasure of oil paint. Eventually you will be choosing your own colours, developing your own compositions and creating unique pictures full of feeling and atmosphere. Above all, you will be having fun. I hope this book achieves everything I talk about and that it inspires you to take instant action!

Spanish Villa

750 x 650mm (29½ x 25½in)

Here, the mass of branches and leaves has been simplified to create an impression of foliage. Take your time when planning your painting, and practise applying quick brush strokes. You will soon learn how to capture complex subjects.

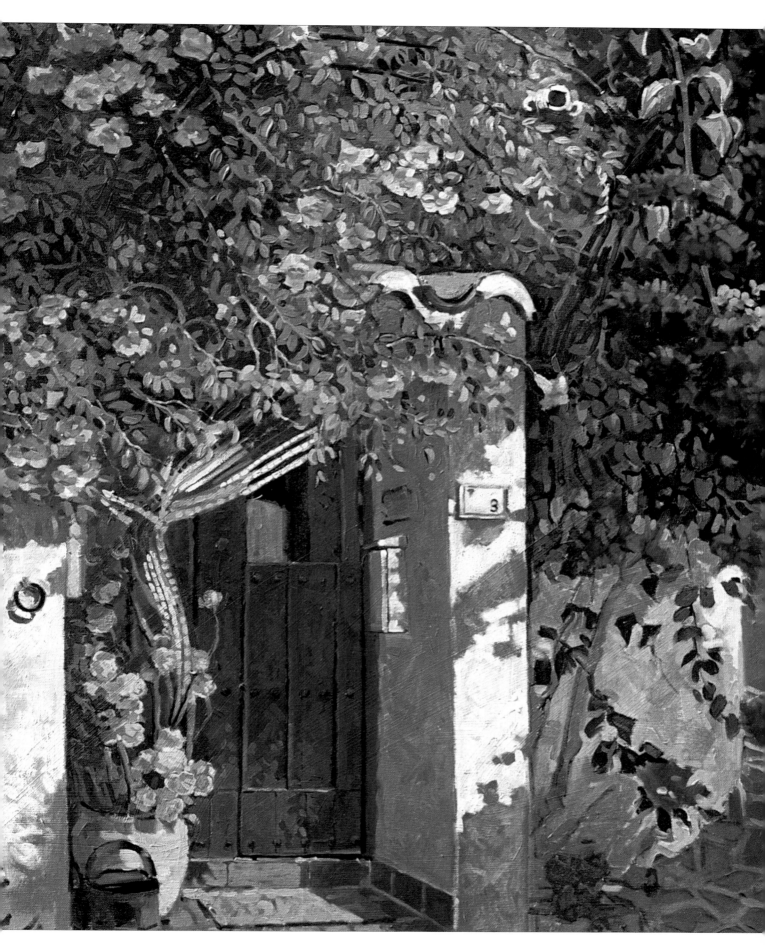

MATERIALS

Choosing your materials from the huge range on offer can be confusing. However, you do not need too much for quick painting techniques. I recommend a few brushes and a selection of good colours. You can add to your collection as you gain in confidence. I would also advise that you buy the best materials you can afford, because you will achieve better results.

PAINTS

Oil paints consist of pigments which are mixed with a binder – linseed oil, poppy oil or safflower oil. Pigments are classified as inorganic (mineral) or organic (vegetable). Raw umber, burnt umber, burnt sienna, cadmium yellow, cadmium red, cerulean blue, chrome yellow and titanium oxide are all inorganic. Ivory black, gamboge and madder are organic. Synthetic pigments were introduced in the 1950s. These were made by distilling coal tar and residues of petroleum and they now include the crimsons, yellows, violets and purples, contributing to a modern range of outstanding beauty and permanence.

Oil paints vary depending on which brand you buy, and ranges include different qualities of colour. The best are artists' quality, because they contain a good quantity of pigment; although they usually take longer to dry, so they are better used in the studio. Students' quality generally contain less expensive pigments and more extender.

It is a good idea not to buy too many colours to begin with, as this can be rather expensive. You can mix many colours from a basic range, and it is a good idea to get to know how to mix colours early on. This is not as difficult as it seems. Following the demonstrations in this book will teach you how to create a good range. There are some excellent starter packs available and these usually contain a good selection of colours, from which more colours can be mixed to extend your palette. A typical starter set should contain the three primary colours: yellow, red and blue – from which all other colours can be mixed, along with several other colours. Always compare prices of packs and single tubes, for it is often less expensive to buy a set.

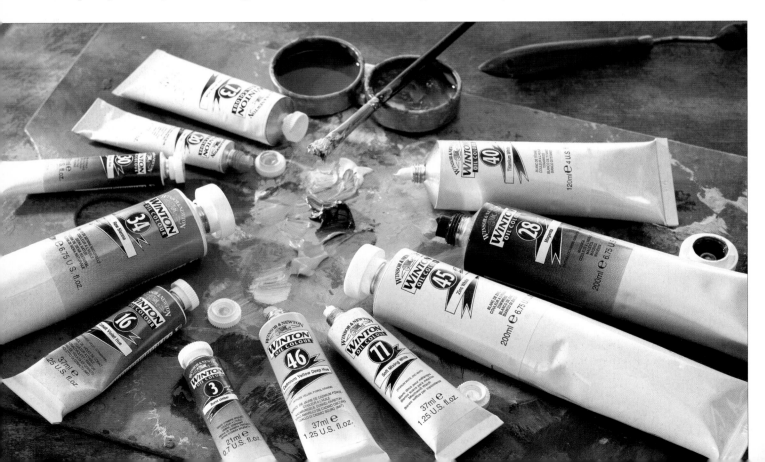

BRUSHES

Artists' brushes are made from natural bristle or hair, synthetic fibre, or a mixture of both. Generally, oil brushes have longer handles than watercolour brushes; and the most commonly used types are rounds, which taper to a point; flats, which have a flattened ferrule; filberts, which are like flats but with slightly rounded corners; and brights, which have slightly shorter bristles than standard brushes.

Natural hair brushes, like the hog bristle brushes, are popular with artists. Their stiff, durable, hard-wearing qualities make them ideal for oil painting. Sable brushes are excellent for detailed work. They are expensive and wear out quickly when used with oils, but no other brushes give the same kind of control, so it is worth buying them.

There are some very good ranges of inexpensive synthetic brushes available and they have recently become very popular. However, I prefer to use those with natural hair, favouring bright brushes and sables, with a fan brush for blending colours.

If you are just starting to paint, it is worth trying out a selection of brushes, because it is only by painting with them that you will develop your own way of working and discover what you like best. My selection works for me and I have become familiar with them, but they would not be everyone's choice. I would recommend that you always buy the best you can afford. Do not be tempted by large inexpensive packs of brushes; the better your equipment, the better your results will be.

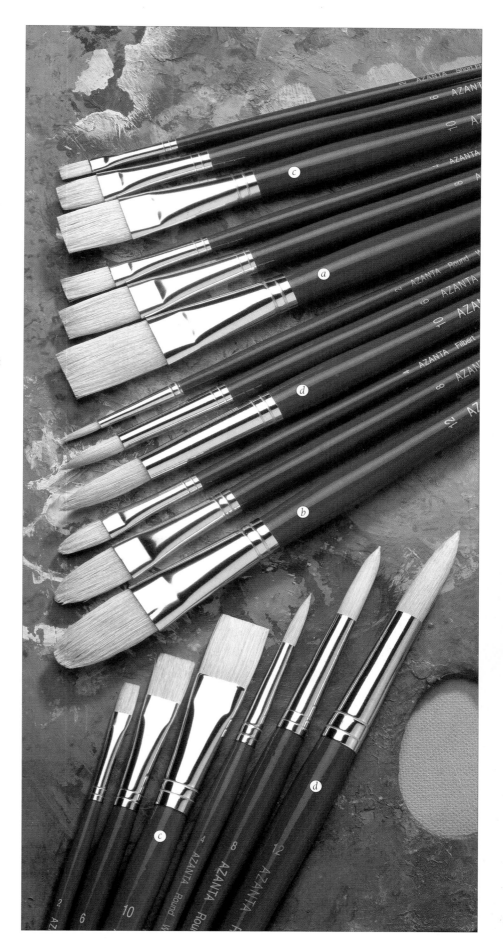

A selection of brushes: flats (a), filberts (b), brights (c) and rounds (d).

9

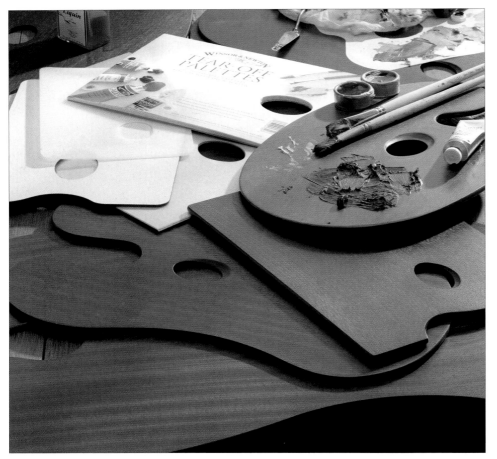

PALETTES

The kidney-shaped palettes that you see portayed in cartoons of artists are still the most used: they are traditionally made of mahogany, and are available in different sizes. Plastic, or wooden palettes painted white, have become popular, as have trays which can be used to lay out and mix colours. Many of my students use cling film over their palettes as a base, which reduces the need for extensive cleaning.

For me, the traditionally shaped, varnished mahogony palette is undoubtedly the best. I have become used to its weight, the way it sits in my hand and the way the dippers are held securely in position while I work. It also gives a professional air and is in keeping with the traditions of oil painting.

A selection of traditional dark wooden palettes, tear-off palettes and a white palette. I prefer to use the traditional kidney-shaped palette, but they are all excellent. The tear-off palette is useful when you want to travel light and the white palette is a good base for mixing colours, because they show up better on a lighter surface.

DIPPERS

Dippers are small metal or plastic containers which are used to hold the solvents and oil necessary for painting with oils. They clip on to the side of the palette and they are available in different sizes. Your choice will depend largely on the scale of the canvas you are working on. Small dippers would need constant replenishment if you were painting on a grand scale.

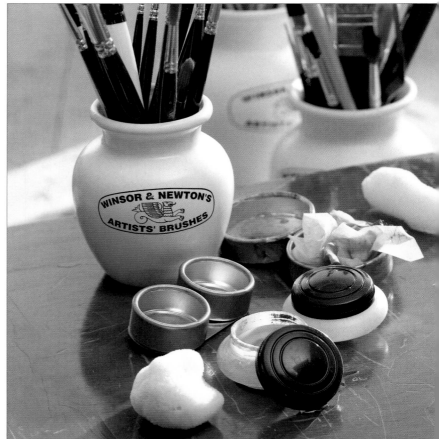

A selection of dippers. Both plastic and metal types are suitable for oil painting.

SOLVENTS

You will need a solvent such as white spirit, turpentine, or a turpentine substitute such as sansador, together with an old cloth or kitchen towel to clean yourself and almost everything else at the end of a painting day.

A distillate of pine resin, turpentine has good wetting properties and is used to dilute oil colours. White spirit makes for a cheaper alternative solvent for thinning paint and cleaning.

Low odour alternatives may be more suitable for some of you and these are available from most artists' suppliers. I never throw away old shirts because they are ideal for cleaning up excess oil paint.

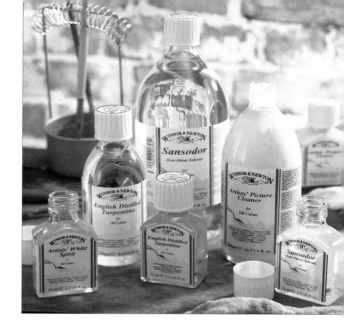

MEDIUMS

There is an amazing variety of mediums available and this may be a little daunting. They are added to oil paints for a number of reasons, most commonly being added to make the paint more workable without thinning it. Try a few, then add to your collection as you grow more confident. You will need linseed oil initially. The following information will help you understand the properties of a good range of mediums.

Artists' gloss varnish A ketone resin and wax blend with white spirit. It is quick-drying and durable.

Artists' matt varnish This has the same properties as gloss varnish, but it dries with a matt finish.

Bleached linseed oil Bleached by prolonged exposure to the sun, this produces a paler oil with a faster drying rate and improved flow.

Cold-pressed linseed oil This reduces the consistency of brush marks and increases transparency and gloss.

Drying linseed oil This contains manganese driers that reduce drying time.

Drying poppy oil A pale yellow resisting oil which reduces consistency and increases drying time.

Refined linseed oil This is one of the most popular of the painting mediums. It slows the drying time, which is ideal for the wet-into-wet painting technique.

Stand oil A non-yellowing retarder for pigment, it imparts a flexible, durable finish to oil paint.

Thickened linseed oil Faster drying than unprocessed oil paint, this improves paint flow.

Wingel This is a free-flowing liquid, which is suitable for building up glazes.

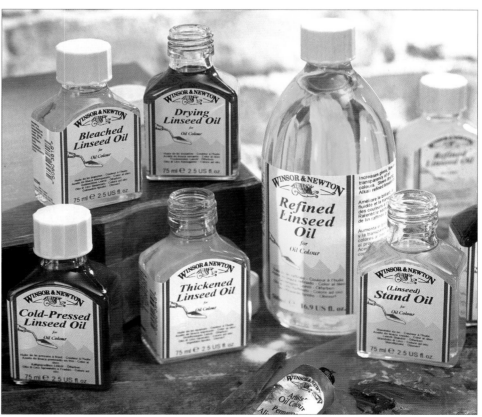

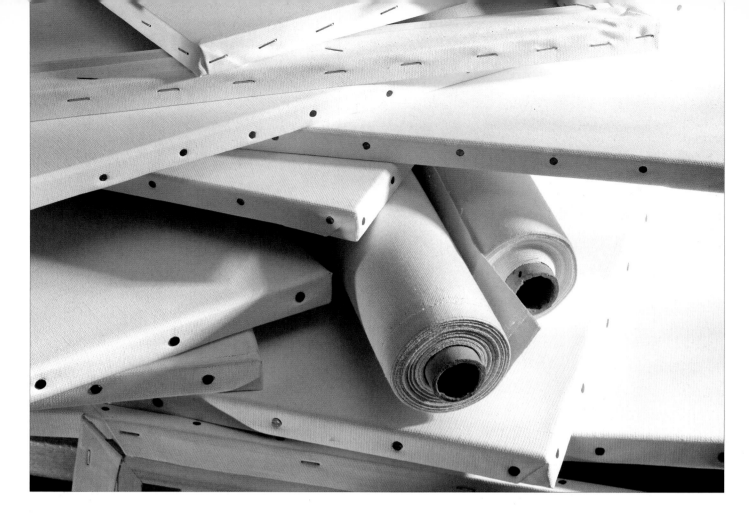

SUPPORTS

So, what do you paint on? I advise painting on stretched canvas and for me, a good quality linen support with a fine tooth is the very best, for it provides movement and allows for subtle paint strokes. Linen, woven from flax, is versatile and extremely resistant to decay, so a high quality fine grain handmade canvas, made from 100 per cent linen, is the best surface to paint on. Synthetic canvases are available, but paint adheres less readily to some kinds of synthetic materials.

The fabric is stretched on to wooden stretcher pieces to form a support for the painting, and then prepared with acrylic primer. The cheapest way to buy a canvas is to stretch it yourself. However, this takes time and a little skill, so I would recommend that you buy a ready-made canvas from your art supplier.

Canvas boards are also available. Acrylic primed fabric is laminated on to stable, high quality boards, providing a firm base for painting. These boards are less expensive, they can be cut down to fit existing frames and they can be stored easily.

Oil colour papers with a traditional canvas-textured surface, are available in pads. They are ideal for oil painting and for outdoor sketching.

Hardboard can be used, but make sure that you use the smooth side. It should be primed with two coats of acrylic primer before you start to paint. If you use the rough side of the board you will ruin your brushes very quickly. It is also an inexpensive alternative for sketching out ideas.

Whether you use a prepared canvas, a canvas board or oil colour papers is really down to personal preference. There are many different sizes, so referring to the sizes I use in this book would be a good starting point.

EASELS

Canvases are usually painted upright (unlike watercolours) and you therefore need an easel when using oils. There is a huge range available, ranging from large studio easels with a box for paints and brushes, to lightweight sketching supports. My first preference would be one that is not too big, so that it is easy to carry. Aluminium easels have this advantage and are easy to erect. Adjustable wooden sketching easels are also very good and have the same qualities. I would advise purchasing one of these initially; you can always buy a bigger easel later on. I have a collection of easels in my studio, all there for different reasons. The one I use most is a draughtsman's table, which is adjustable from flat right through to an upright position, and it can be moved to any height. This, of course, is far too heavy and impractical to use outside.

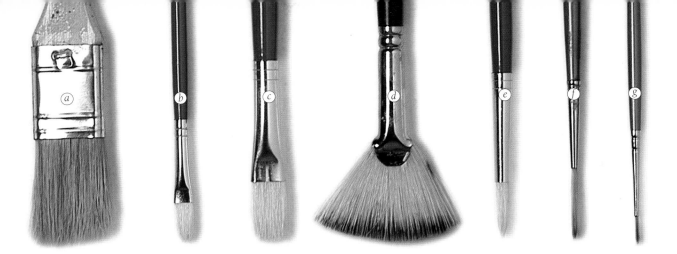

BRUSH TECHNIQUES

What are brushes for? This may seem a silly question but even after a lifetime of painting I still do not understand what all the different brushes do, and I always stick to my tried and tested favourites.

Here I show you a good range to use if you are just starting out. I also show how to hold each one to achieve the best results. After practising the brush strokes you may well want to add to your collection. It is a matter of personal choice and each artist is different, so try other shapes and sizes.

Tip

Cleaning is easier if paint is removed with a kitchen towel and the brushes are soaked in white spirit. Any remaining paint can be removed with washing up liquid and warm water. Leave the brushes to dry with their shape restored as near as possible to their original shape.

a) 1 inch masonry brush This is used to paint large areas. It is also used for blocking in areas of colour at the start of a painting.

b) Short flat size 2 This is excellent for smaller areas and detail. The sideways motion of this brush produces thin lines and downward strokes produce thick lines.

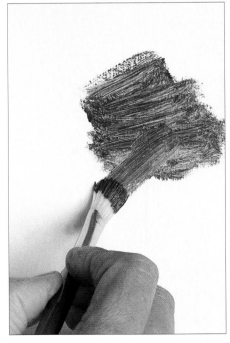

c) Filbert size 6 A good brush for drawing and general painting, but not always suitable for fine work. Filberts and brights were the brushes of choice for the Impressionists.

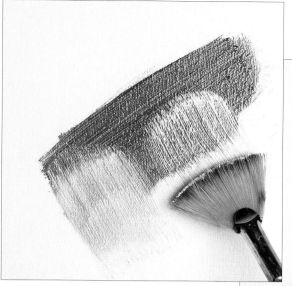

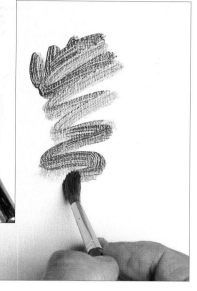

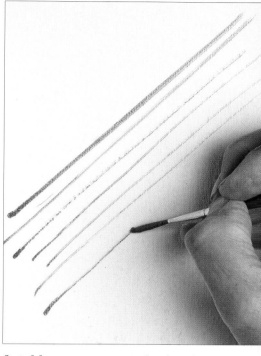

d) Fan fine hog size 8 Fan brushes of any size are extremely good for blending and softening wet-into-wet areas.

e) Round size 4 This is ideal for smaller areas and detail like a bright brush, with perhaps an added corner softness.

f) Sable rigger size 2 This brush produces a fine line, is capable of holding good amounts of pigment and is ideal for details like the rigging of boats, hence its name.

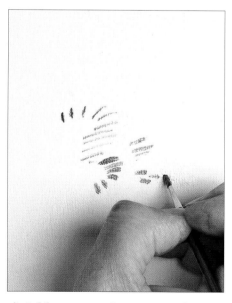

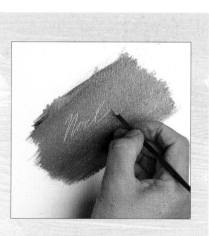

g) Sable size 1 This is a good brush for all fine details and for accurate drawing.

Mahlstick

This provides stable support for the brush hand when painting detail. It is held in the hand that is not using the brush, with the padded end resting on the canvas. It is as useful to the artist as it is to the calligrapher.

Cut brush handles

By cutting the end of a brush you can draw or use it to sign finished work by exposing under colour or white canvas.

GETTING STARTED

After spending money on materials, you now have to make a mess of them by actually using them! This stage is very exciting: squeezing tubes of paint, trying to open bottles of solvent and linseed oil without spilling any, adding colour to fresh, new brushes – and actually ruining a pure, white canvas. It is daunting facing a blank white surface with your brush poised for the first time. If you expect too much, you may never do another painting. If you lack confidence, you will not achieve good results. With my students I have noticed that it is generally their first efforts that determine whether or not they will retain their enthusiasm for painting. If they have started off with impressive results, they are hooked for life.

UNDERSTANDING TONE

This is the most important task when painting pictures. It is also the hardest to understand and the one thing that the beginner gets wrong most often. You can get around bad drawing and choice of colour, but you have to understand about tone in order for the picture to work.

One easy way to discover how tone works is by squinting your eyes. This reduces detail and simplifies dark and light areas. No matter how much experience you have, underestimating tonal values is a common occurrence. Look at these photographs of a peach. See how dark the shadow areas are when you have your eyes half-closed.

The clock

1 Hour

This symbol accompanies the demonstrations and gives an approximate indication of how long each painting took me to complete. Please do not regard this as a set time because the time taken will depend upon your level of skill. A complete beginner will take longer than an experienced artist.

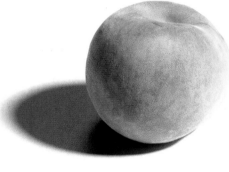

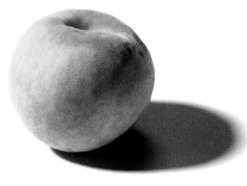

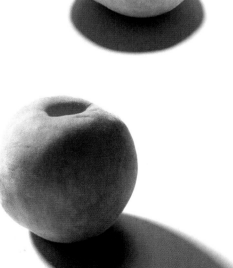

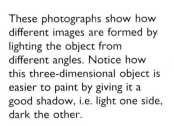

These photographs show how different images are formed by lighting the object from different angles. Notice how this three-dimensional object is easier to paint by giving it a good shadow, i.e. light one side, dark the other.

Tip

To create shadow areas use some of the colour that exists in the objects mixed with blues and purples. Try not to use black if you can help it. I am not saying do not ever use black, but try and get the same effect using the darker colours in your palette.

Shadows are not all dark, but are made up of different tones. They also reflect the colours around them.

Peach

1 Hour

In this demonstration, I will show you how to paint a purely tonal image in order to show the importance of this aspect of painting with oils. First of all, you should look for a subject that does not require a great deal of drawing skill. I have chosen a peach, but it could equally well be an orange or apple. The round fruit shape is especially good because it can be represented without extreme accuracy and still look realistic.

Painting the background light behind the darker tones of the peach and dark behind the lighter tones makes the fruit stand out. It also helps to define the shape of the subject and its shadow. This can be applied to any image.

You will need

Canvas board, 300 x 250mm
(12 x 10in)
Brushes:
 Hog filbert size 8 (large)
 Short fat bright size 2 (small)
 Sharpened brush handle

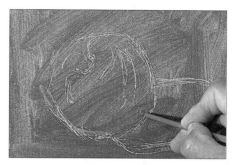

Colours

Lamp black

French ultramarine

Titanium white

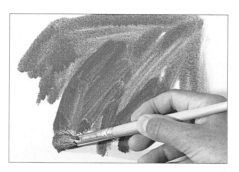

1. Using a mix of French ultramarine, lamp black and titanium white, and a large brush, block in the blue-grey background. Scrub the paint randomly over the whole area.

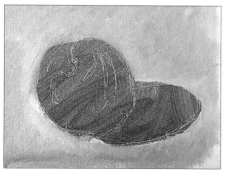

2. Using a sharpened brush handle, draw the outline of the peach and shadow into the paint, defining the lighter areas.

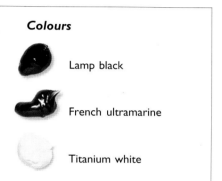

3. Paint titanium white into the background around the outlines of the peach and shadow. This will throw them both forward and accentuate the shapes.

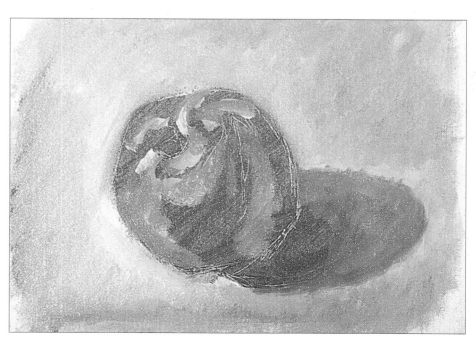

4. Keep painting white into the lighter areas and darker tones into the shadow areas, moving the colours around and blending them as you work.

Tip

It is the mastery of tone that makes a painting exciting, so even your first picture can be inspirational.

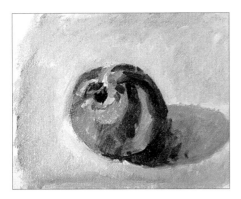

5. Using a dark mix of French ultramarine and ivory black, paint in the darker areas. Work and blend the colours in and around the peach.

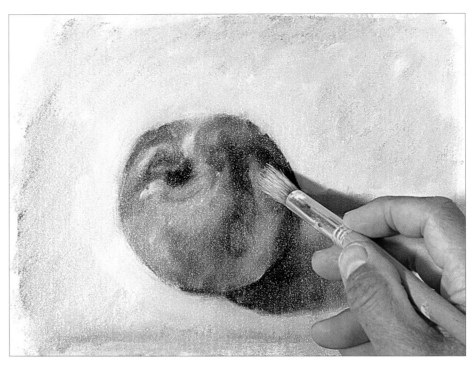

6. Using a large, dry brush, blend and soften the tones, working over the peach, shadow and background.

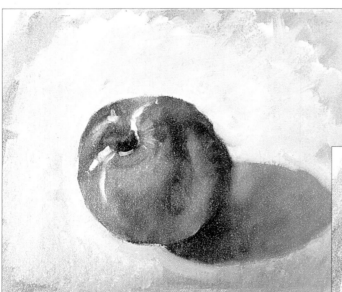

7. Reinstate the white areas, so redefining the shape of the peach. Work the paint into the background blending the tones. Add white highlights with the small brush.

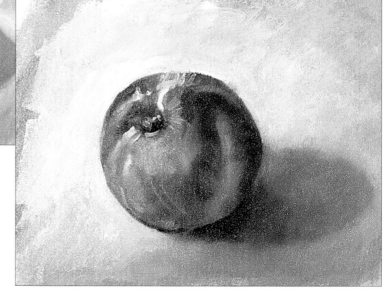

8. Tighten up the outlines, still working light tones into the peach. Blend the paint into the background and darken the shadow of the peach. Use the large, dry bristle brush to blend the colours.

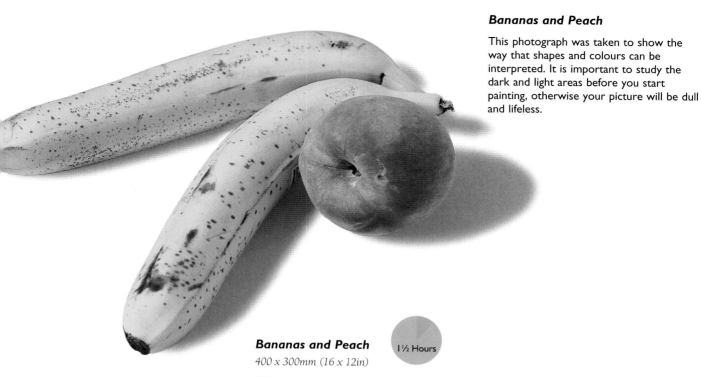

Bananas and Peach

This photograph was taken to show the way that shapes and colours can be interpreted. It is important to study the dark and light areas before you start painting, otherwise your picture will be dull and lifeless.

Bananas and Peach
400 x 300mm (16 x 12in)

1½ Hours

This tonal study uses the same techniques that were demonstrated in the previous painting. It is important to look at the tones of any object or subject you are painting. Without tone, any pictures that you paint will be lacklustre. Here, the bananas and the peach were painted in sunlight, so the shadows are fairly strong.

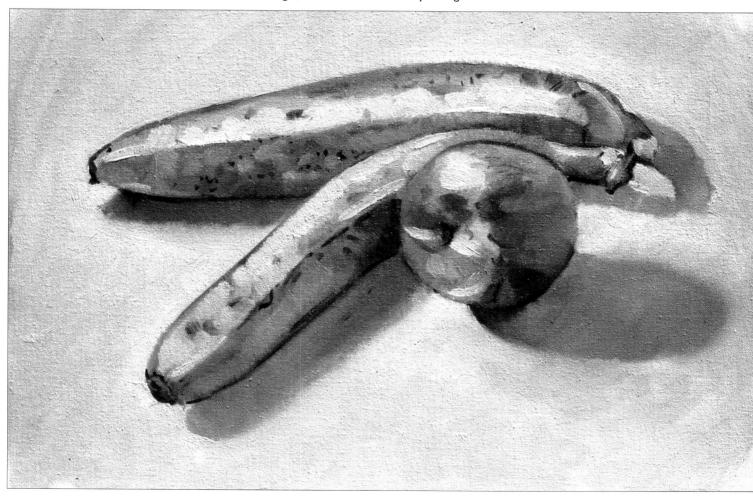

USING COLOUR

Do not let yourself be intimidated by colour. Virtually all colours can be replicated by mixing the paints on your palette. I have built my collection of oils up over the years, but it is by no means the ultimate range and never could be: colour ranges are as personal as painting technique; and through a process of trial and error you will find the colours and techniques that work best for you.

When painting in oils, do not worry too much about whether you can mix a certain hue or not: experience will give you the knowledge in time. I would advise anyone to do as many colour wheel mixes as possible, because time spent learning how each paint relates to others is time well spent.

MY PALETTE

Cadmium red

A primary colour essential for the palette. A strong vibrant red that will do for most mixes that have even the slightest hint of red in them.

Alizarin crimson

A transparent red that will help you gain a range of warm colours impossible to mix with any other red. For example, I cannot paint bougainvillea flowers at all without this colour. It is also good for skin tones.

Permanent mauve

The comments on cobalt violet apply well to permanent mauve. Mixed with white, permanent mauve is a great help in flower painting.

Cobalt violet

Strictly speaking, this can be mixed from other colours, but I prefer to use it straight from the tube for quickness and purity. It is a beautiful blue-red and can be used well in shadow areas and skin pigment.

Cobalt blue

This is indispensible for landscape painting, giving a huge range of sky and foliage colours, much like French ultramarine.

French ultramarine

One of the most important primary colours to have in your box. Essential for all picture making, especially skies.

Cadmium yellow

Another essential primary colour from which most yellows can be made. It is an extremely strong pigment and mixes with blue (and other colours) to produce all the landscape greens you could wish for.

Lemon yellow hue

This yellow is a pure, light colour that brightens up greens and is great for adding straight on to the canvas to represent flowers, as in the demonstration on page 40.

Winsor blue (red shade)

Like cerulean blue, this will give you a range of blue mixes impossible to achieve with any other pigment. If you have never tried it, do so. It is very exciting for shadow areas.

Cerulean blue

A very strong blue that may not have a direct reference to nature's blues, but is essential to brighten up shadow areas as well as adding a huge range of bright colours when mixed with other paints.

COLOUR EXPLAINED

Colour is divided into hue, temperature and density. A hue is the specific name of a colour; e.g. yellow, red, blue-grey etc. There is an almost infinite range of hues, the most popular and useful of which are available as off-the-shelf oil paints (e.g. cadmium red), and others which you have to mix yourself. Density is the strength of those colours; and is reduced when the colour is mixed with another hue or white. Temperature, simply put, means blue colours are cool and red colours are hot; although there are exceptions. Lemon yellow, for example, is cool in comparison to yellow ochre.

In order for you to understand colour, the following is a good exercise. Start with the primary colours red, blue and yellow. Here, I use alizarin crimson, French ultramarine and cadmium yellow. These colours will enable you to produce the secondary colours green, orange and purple. If you mix the resultant secondary colours with the adjacent primary colours, you will see that all the other colours, within reason, can be obtained by various mixes.

Yellow ochre

Important for all picture making and although it can be mixed quite easily, it is better to have a tube to hand – especially for landscape painting.

Naples yellow

It is always convenient to have a selection of yellows on the palette, and Naples yellow will give you a whole range of colour mixes without being too brilliant. Mixed with blue, it makes a fine green for landscape painting.

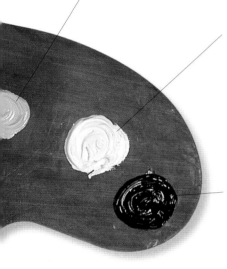

Titanium white

In the past flake white was the choice of the artists, but because of its lead content, it is not easily available today. Titanium is a good white, slightly less vibrant than flake, but very suitable for all colour mixes.

Lamp black

Not all artists recommend the use of black. I sometimes use it in the really dark shadow areas or to bring out strong tone, but it can be very dulling in picture making.

Burnt sienna

An earth colour used for all painting to reduce the strength of pure colours, to make subtle landscape blends and so forth.

Burnt umber

An earth colour essential for colour mixes that need a darker tone. It also elevates the use of black.

Viridian

I use viridian a lot. It can be difficult to control the strength but it is a great help in shadows and has application for skin tones in the dark areas.

Sap green

This is a very strong pigment and will save time in landscape painting if you are using a lot of green. Although not essential, it will give you an acid spring leaf colour quickly.

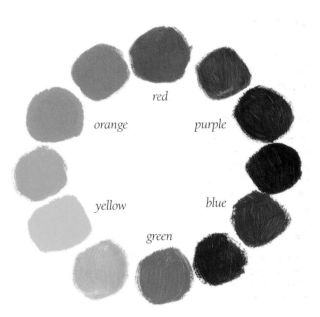

red

orange

purple

yellow

blue

green

When you have completed your wheel, add small amounts of white to each colour and extend them outwards from the original hue to almost pure white. This will give you the hue's range.

Tip

Lay the colours on your palette. Keep mixing them as you work on the painting, dipping into the mixes and blending the colours with linseed oil.

COOL COLOURS

After doing a colour wheel, let us paint a subject that incorporates part of the colour spectrum. I have chosen cool blues and greens for this demonstration. You will notice that I have not used too much detail. This enables me to work quickly and I can change things, working on the subjects as well as the background. I use a wet-into-wet technique that enables me to create subtle changes of colour by mixing on the palette as well as on the painting itself.

1 Hour

You will need

Canvas board, 400 x 300mm
 (16 x 12in)
Brushes:
 Flat fine hog size 8, (large)
 Bright size 2 (small)
 Sable size 1 (detail)
Turpentine
Linseed oil

Colours

 French ultramarine

 Cobalt violet

 Cadmium red

Cadmium yellow

 Titanium white

1. Mix French ultramarine with titanium white and a little turpentine to thin the paint. Lay a wash over the whole area with a large brush, applying the paint to the canvas randomly. At this stage it is important to start covering the whole surface of the canvas.

Tip

When blocking in colour, brush strokes can be freely applied vertically, horizontally and diagonally. These colours form a base and you will be building up layers of paint on top, so do not worry about how the paint is applied at this stage.

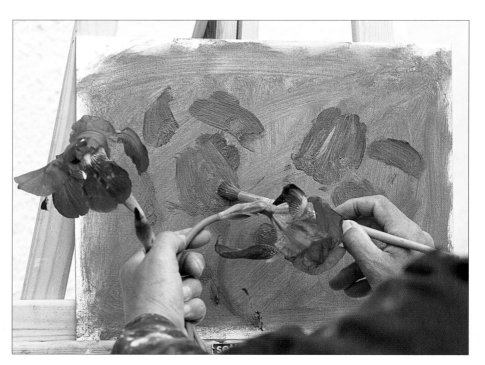

2. Block in areas to indicate roughly where you are going to place the individual blooms, using cobalt violet and a large brush. Brush strokes can be free and random, moving and blending the colours into the surface.

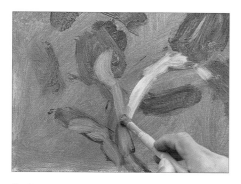

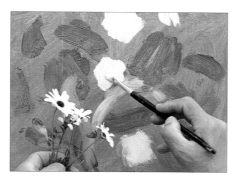

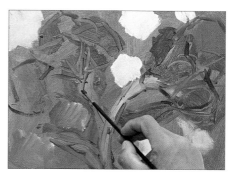

3. Now add a little linseed oil to thicken up the colours. Using French ultramarine and cadmium yellow, mix a green and indicate the stems. Add a touch more yellow and titanium white to highlight areas.

4. Change to the small brush, and working wet-into-wet, use titanium white mixed with a little linseed oil to add the lighter flowers, then paint in the mauve daisies using a mix of cobalt violet, cadmium red and a touch of titanium white.

5. Change to the detail brush and draw the iris flower heads with the same mix darkened with French ultramarine; loosely outline the shapes and darker stem areas.

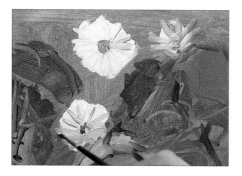

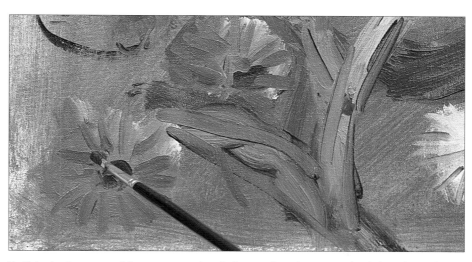

6. Using the same blue mix, roughly paint in the white daisy petals and flower centres. Do not worry if your colours merge, this is all part of the painting process and colours can be built on later.

7. Paint in the mauve daisy centres and radiating petals, using a mix of cobalt violet and French ultramarine. Work quickly to capture a feeling of liveliness and spontaneity. Do not overwork your colours.

8. Change to the small brush, and using titanium white, start blending the background colours around the flower and stem outlines, redefining the shapes.

Tip

Use several brushes and you will not have to keep cleaning your brush every time you use another colour. This will speed up your painting.

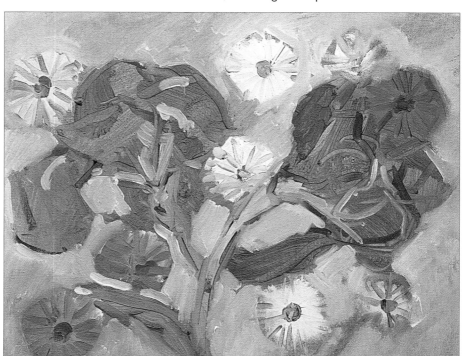

9. Using the detail brush, paint titanium
white highlights on the right-hand iris.
Then, with French ultramarine, redefine
the flower head and paint in contrasting
tones with areas of cobalt violet.

10. Using the large brush, paint more
titanium white into the background around
the flower head to throw it forward. Add
the iris stamens using cadmium yellow and
cadmium red. The paint should now be of
a thicker consistency to add a little texture
to the composition.

11. Repeat the process on the left-hand
iris. Using French ultramarine and cobalt
violet, paint in the blue and purple tones,
mixing the colours on the palette and on
the canvas. Add white veins, and the
cadmium yellow markings.

12. Using the detail brush, keep working
into the daisies, blending, merging and
mixing colours, and adding titanium white
to create lighter tones. Brush strokes
should be worked from the centre of the
flower outwards.

13. Using French ultramarine, add the dark centres. Keep painting over the whole surface of the picture, building up the colours everywhere, continually moving and blending the paints.

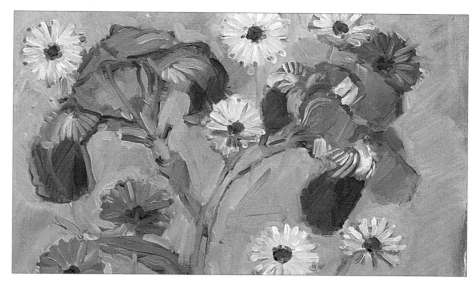

14. With very little linseed oil worked into the paint, lay dark French ultramarine in between the petals of the daisies. This will sharpen the contrast in the white and red flowers, and throw them forward. Lighten the background and lay in paler shades of green with a cadmium yellow and French ultramarine mix. Build up the tones on the irises, using cadmium violet, working from the centre outwards and blending the colours. Apply thick white paint, straight from the tube, on to the white flowers. Finally, add white highlights to the stems and flowers.

The finished picture

400 x 300mm (16 x 12in)

At this stage, when the painting is almost finished, intensify the darks and lights to give a feeling of depth, then stand back and look at your painting. If you are not happy with something, it is easy to wipe away the paint and re-do areas, or add more paint.

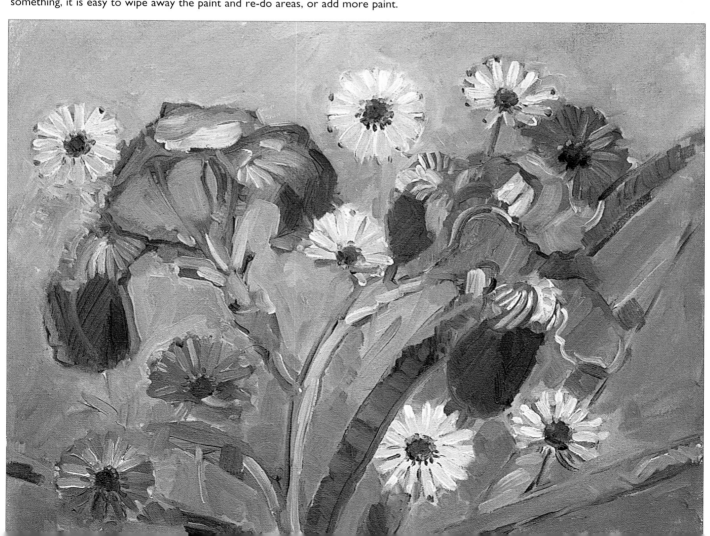

Avocados, Lemons and Tomato

550 x 460mm (21½ x 18in)

This is an example of a cool composition which has been painted in the same way as the demonstration on the previous pages. Although haphazard, it works well because of the overall balance of dark and light.

There is an important added element of design here. By using a complementary hot coloured object, in this case the tomato, the contrast enhances the cool colours in the painting. Notice just how dark the shadow areas are here. In this case it was natural sunlight, but it could equally have been a spotlight in the studio.

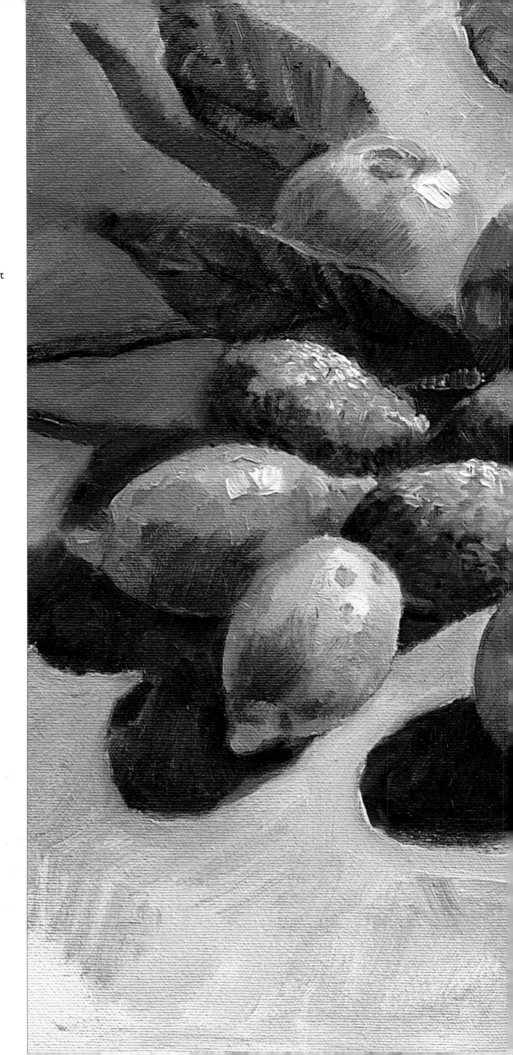

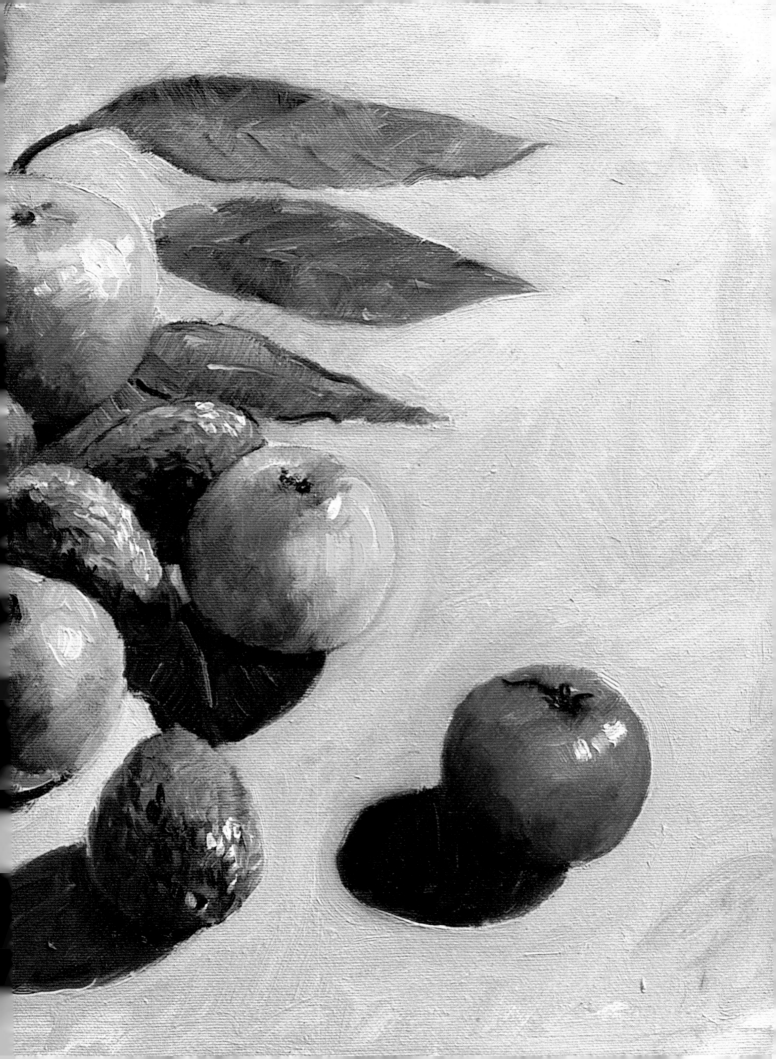

HOT COLOURS

This demonstration of warm and hot colours shows a selection of red and yellow flowers in a glass vase. Rather than being an exercise in how to paint flowers, the aim of this is to help you mix some of the hot colours of the spectrum so that you learn about the difference between cool and hot colours.

1 Hour

You will need

Canvas board, 400 x 300mm
 (16 x 12in)
Brushes:
 Filbert size 6 (large)
 Small flat size 2 (small)
 Sable size 1 (detail)
 Fan size 8 (fan)
Turpentine

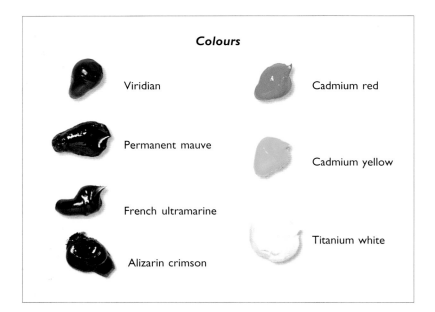

Colours

Viridian

Permanent mauve

French ultramarine

Alizarin crimson

Cadmium red

Cadmium yellow

Titanium white

1. Using the large brush, block in the background with a mix of cadmium red, cadmium yellow, French ultramarine and a touch of turpentine.

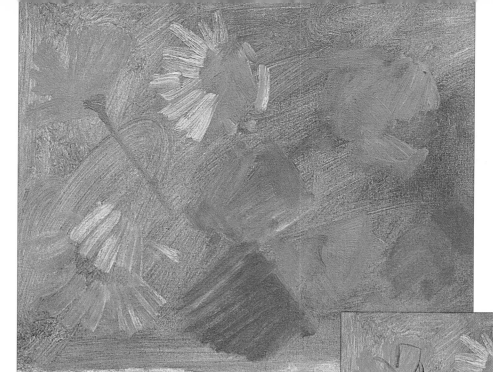

2. Using the large brush, rough in the largest areas, loosely indicating the shapes of the flowers with cadmium yellow, cadmium red and an orange mix of the two colours. Add in the stems using a green mix of cadmium yellow and French ultramarine.

3. Use viridian to draw in the outlines. I have chosen this colour because some of the green can remain in the finished painting and it stands out well against the other colour structures.

Tip

When painting complicated flower heads like the geranium, simplify the subject. Here just add spots of colour to indicate the petals. Adding tones of red will make them spring to life.

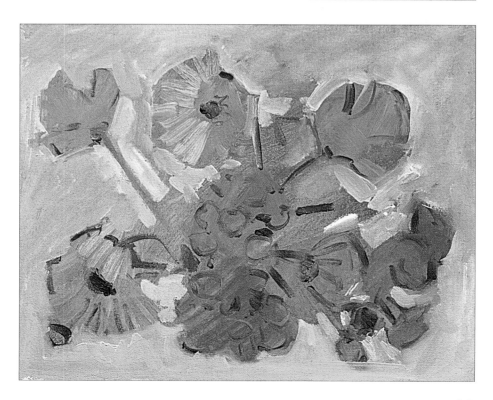

4. Adding titanium white to the mixes on the palette, go over the background around the flowers to bring them forward. The white will mix with the paint underneath and produce a subtle tone that is in keeping with the rest of the canvas.

29

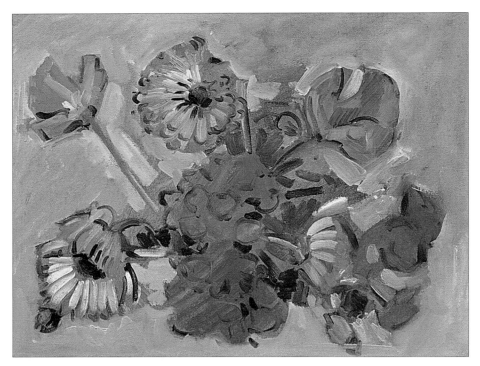

5. Keep adding detail to all the flowers. This need not be every petal in each position, but add to the general appearance and shape. Also, by adding dark green – a mix of viridian and alizarin crimson – the shape of the larger blooms can be better understood.

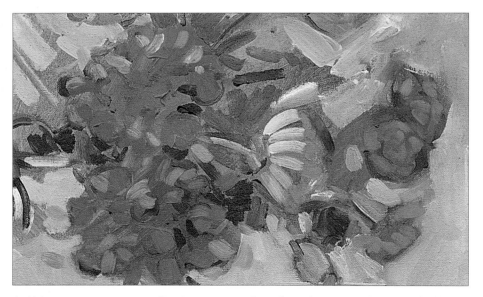

6. Using permanent mauve, alizarin crimson and touches of titanium white, start building up the colours in the geraniums. Do not work the colours together too much. Vary the tones, adding light and dark areas. The white will turn pink as the colours merge. Add touches of French ultramarine. Work the reds into the carnations, varying the tones in the same way. Using a mix of cadmium yellow and titanium white, work the colours into the background, then blend them together with a large, dry brush.

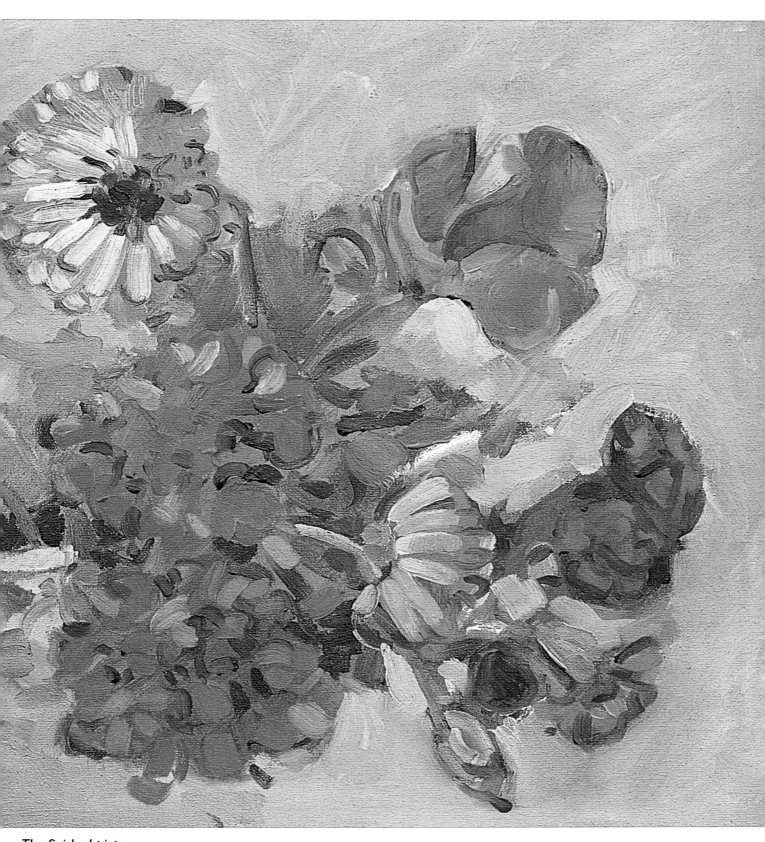

The finished picture
400 x 300mm (16 x 12in)

The picture was completed by adding some dark and light highlights to the flowers, followed by a little blending with the fan brush to soften the effect. This picture, and the one on page 25, are, if you like, sketches in colour which aim to help you understand mixing not only on the palette, but on the painting itself.

Oranges and Lemon

550 x 460mm (21½ x 18in)

This is a companion painting to the one on page 26 and it is composed just like the cool painting. The hot colours have been made to appear more intense by the use of contrasting French ultramarine in the background. Notice again how important the use of shadows is in the composition. Painted out of doors, and formed by sunlight, these strong three-dimensional images are achieved by using intense tonal contrasts; i.e. over-emphasising the very dark and very light.

4 Hours

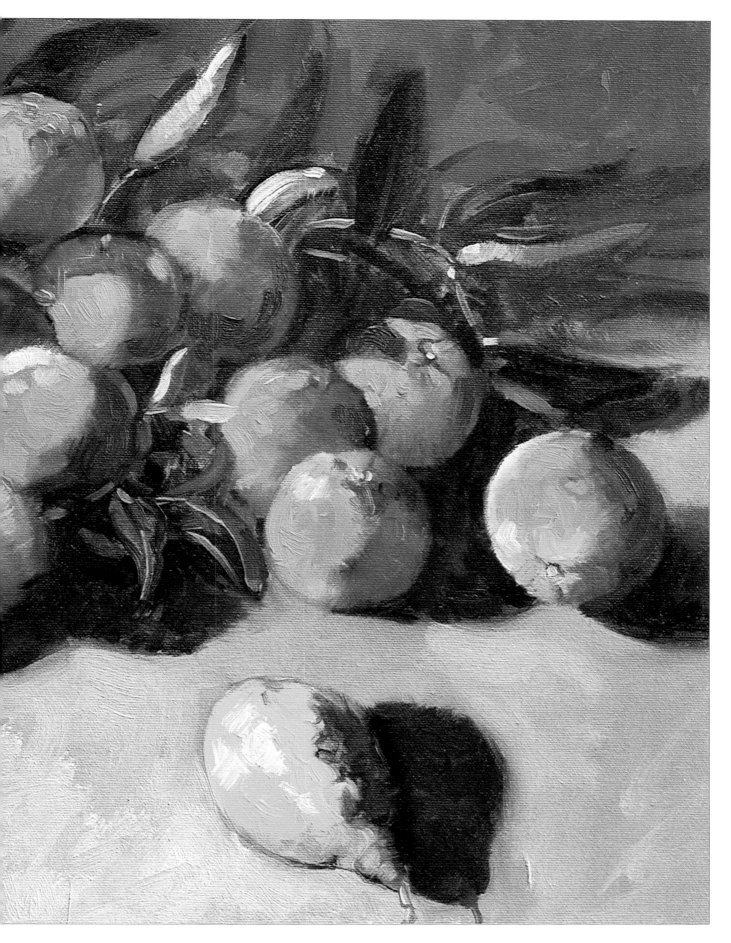

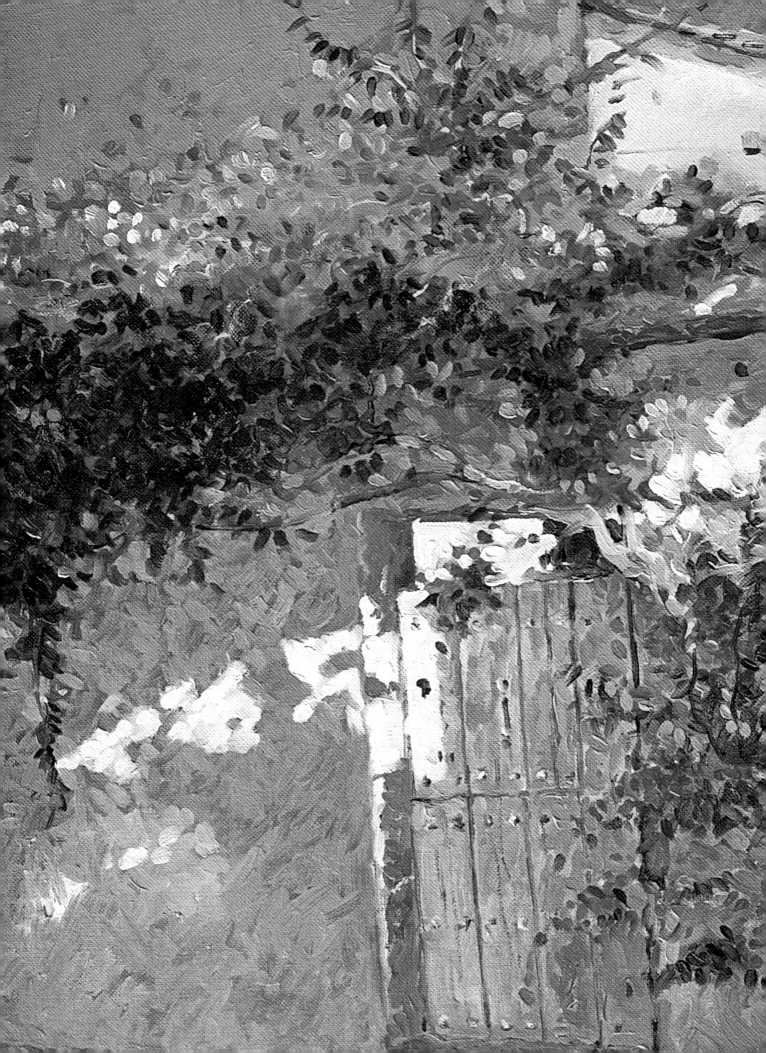

TREES

Trees can be intimidating for beginners. At first glance, they look very complicated with their hundreds of branches and myriad leaves. However, if you just treat the tree as an abstract object and break it down into shapes, it can always be seen as a simple form.

Pay little attention to branches and twigs at first: treat everything as a flat area. A painted sky can then be added, and a background will help to give shape and form by covering the canvas ready for the next stage. Always consider the adding of individual leaves and branches as the final part of the painting process.

If you treat trees in this way, you will soon overcome any initial nervousness and find painting them very rewarding and creative.

4 Hours

White Door

560 x 400mm (22 x 15¾in)

Strictly speaking this is a landscape, but I have included it in the tree section because it is effectively a tree with a different background. Using the same techniques that are explained in the following pages, an initial wash was laid on to canvas board with a mix of turpentine, cerulean blue and titanium white. The drawing was then added using a small sable brush and strong purple. All the main divisions of the composition were placed at this drawing stage. Then, with the addition of the bourgainvillea shapes placed in pink, the picture began to take shape. One of the beauties of painting wet-into-wet with a base colour is that with the addition of just pure white, you can change the tonal structure of the whole by using this in the light areas.

Mimosa

2 Hours

Here I show you how to paint a tree, starting from its simplest form. In this instance the model is only a small tree about ten foot high; but it is pretty, and the background rocks give it a good silhouette shape, and one that is not too complicated when first starting out.

Colours

- Sap green
- French ultramarine
- Lemon yellow
- Alizarin crimson
- Cadmium yellow
- Cobalt blue
- Cobalt violet
- Titanium white
- Winsor blue

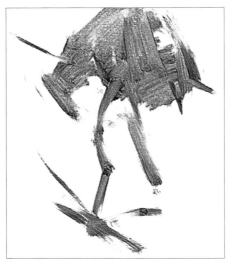

1. Using a large brush, mix an earthy green using sap green, titanium white and a touch of alizarin crimson. Add a little turpentine to the mix and block in the main areas.

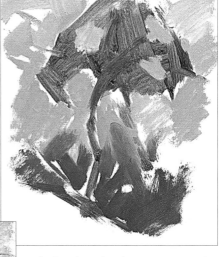

2. Brush in the sky using a mix of cobalt blue and winsor blue, then indicate the rocks with cobalt violet and titanium white. Mix French ultramarine into the violet to create darker tones and paint in the darker areas.

3. Using the small brush and a mix of French ultramarine and alizarin crimson, outline the trunk and the branches loosely and quickly, working from the centre of the tree outwards. Next, paint in the dark background tones with a mix of French ultramarine, cobalt violet and titanium white. Using a mix of alizarin crimson, cadmium yellow and French ultramarine, block in the ground around the base of the tree.

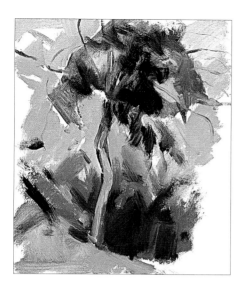

4. Using a mix of viridian, French ultramarine and alizarin crimson to create a dark green, paint in the dark green foliage areas and the background. Reinforce the trunk of the tree with the background mix.

5. Indicate the lighter green leaves with short brush strokes and the green mix with added titanium white. Follow the general shape but work at slightly different angles. Overlay the brush strokes as you continue painting.

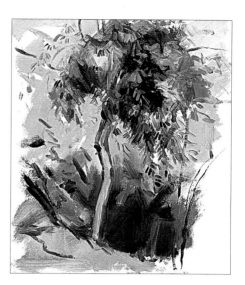

6. Sky 'windows' can now be painted into the tree, using a mix of French ultramarine and titanium white. Laying the paint on like this has the effect of redrawing the shape of the tree.

Tip

Notice how the colours on the palette are now mixed with each other, creating light, medium and dark tones. Keep adding tube colours to the mixes to keep the colours lively and use the same mixes, which will give a harmonious feeling to the painting.

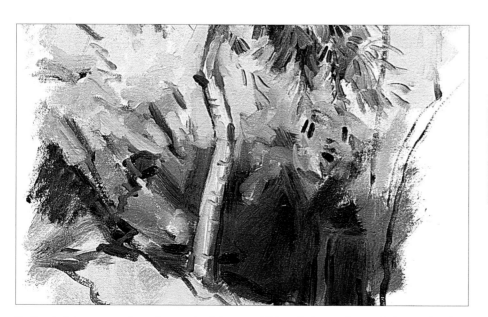

7. Brush lighter tones into the trunk of the tree. This will throw the trunk forward and push the rocks back.

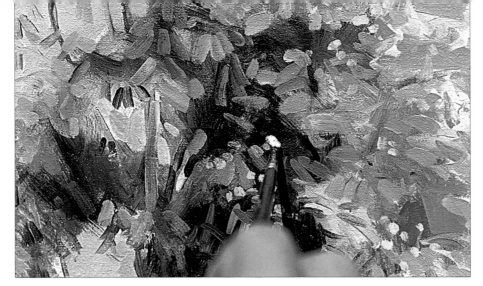

8. Using the detail brush and a mix of lemon yellow and titanium white, dab on the flowers. The blooms are not all the same yellow, so add a touch of alizarin crimson to create a warmer yellow for contrast, then paint in some more flowers.

9. Work in some titanium white highlights and lighter tones over the leaves and branches.

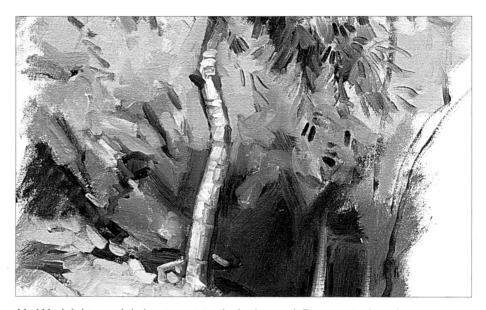

10. Using a worn, stiff brush, carefully scratch out the branches, drawing them out so that the ends taper into fine lines.

11. Work lighter and darker tones into the background. Do not mix the colours too much on the canvas. Lay the colours on next to each other, building them up to create areas of light and dark.

12. Soften the background with a large dry brush, working over the whole area to blend the colours, Keep wiping the brush clean with the cloth rag to ensure that you do not muddy the colours when blending.

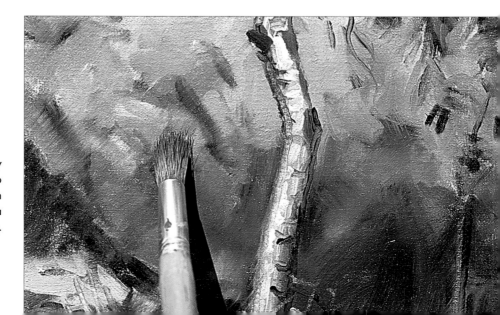

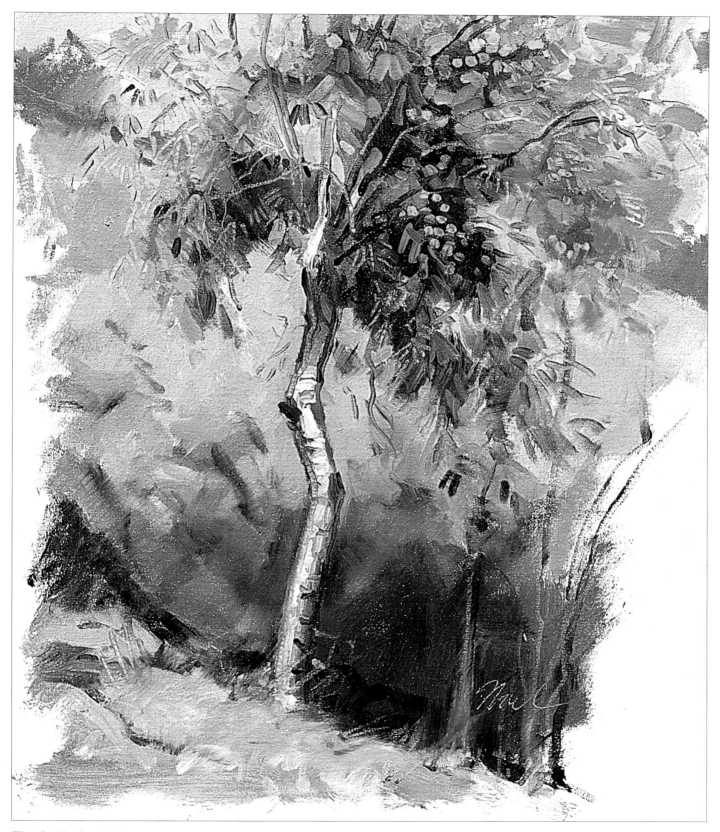

The finished painting

220 x 270mm (8½ x 10½in)

This painting has plenty of life and spontaneity. The leaf areas have been replaced by simple brush strokes in keeping with the feathery feel of the tree. All trees can be painted in this way, as long as you remember to keep them simple at first.

Spring Tree

2 Hours

This demonstration of an almond tree in full blossom shows another way of painting a tree. The sky and background is painted first, with a few of the larger branches as a guide. The blossom areas and leaves are removed by using a cloth containing white spirit. This can only be done before any paint has dried, and it produces a softness that is unattainable by any other method. Detail can then be added over these removed areas, but try not to cover them completely otherwise this texture will be lost.

You will need

Canvas board, 450 x 330mm
 (18 x 13in)
Brushes:
 Filbert size 6 (large)
 Round size 4 (small)
 Sable size 1 (detail)
White spirit
Cloth rag

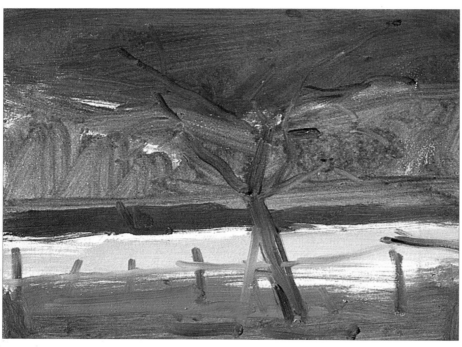

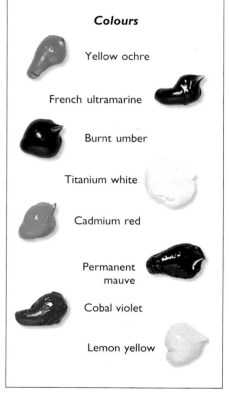

Colours

Yellow ochre

French ultramarine

Burnt umber

Titanium white

Cadmium red

Permanent mauve

Cobal violet

Lemon yellow

1. Mix a little yellow ochre with French ultramarine. This will give you the general colour wash of the background greens. With a thin wash of French ultramarine, paint the general shape of the sky; and with burnt umber the basic shape of the tree. Add titanium white and a small amount of cadmium red to the green mix for the fence colour.

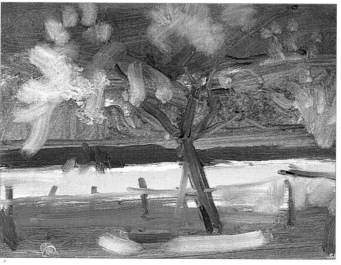

2. Using a cloth containing a small amount of white spirit, remove the simple shapes of the general mass of the leaves, leaving the white of the canvas showing (right).

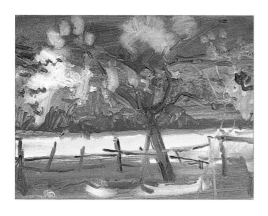

3. Draw in the main branches behind the areas removed by the white spirit with burnt umber.

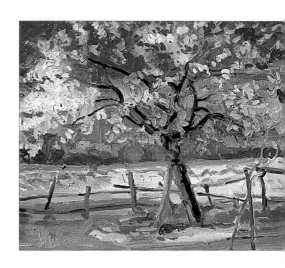

4. Redefine the sky with a thicker mix of French ultramarine and titanium white. Detail the fence using burnt umber. Finishing the picture is a matter of adding colour in a thicker consistency with the addition of permanent mauve, cobalt violet and pure lemon yellow for the flowers.

The finished painting
450 x 330mm (18 x 13in)

I added some finishing touches to complete this painting, including the addition of pure white for the reflected light in the blossoms, and a few darker greens to represent leaves and ground detail. This little picture is a happy subject made dramatic by the use of a very dark blue sky.

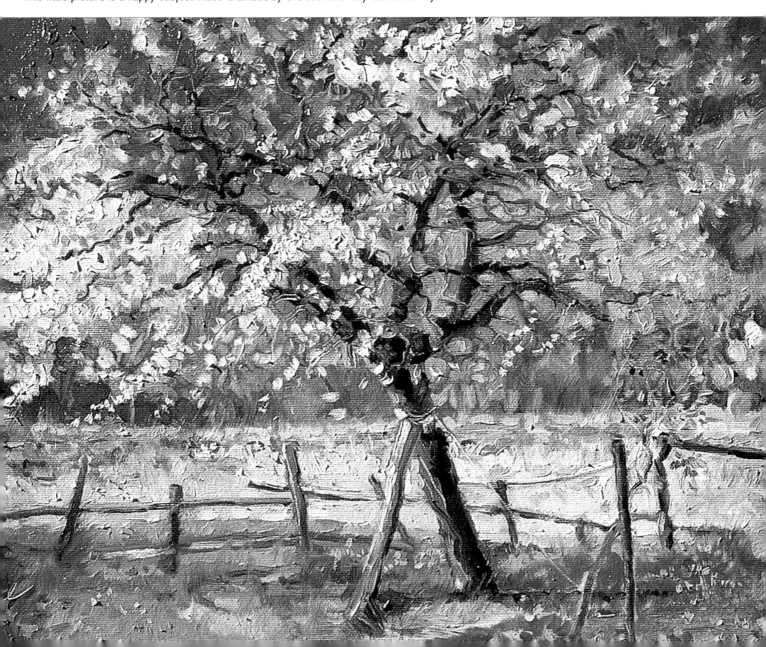

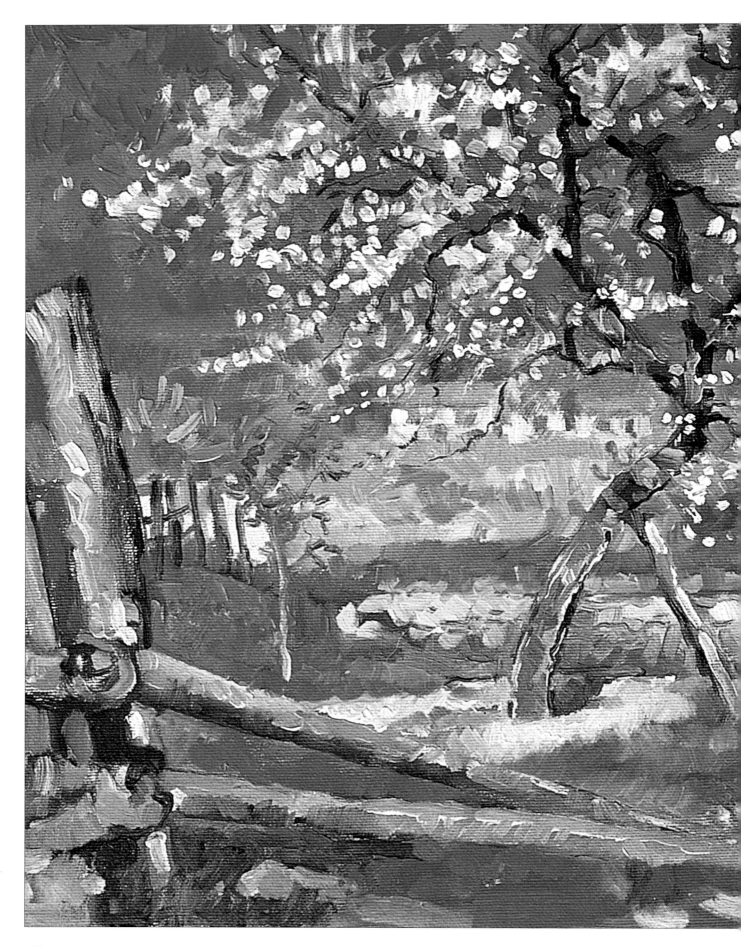

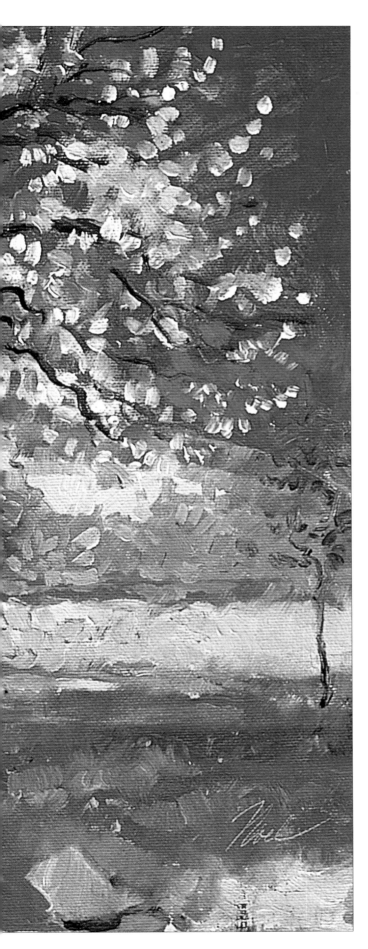

Almond Blossom

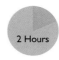
2 Hours

450 x 330mm (18 x 13in)

This is the same tree as the demonstration on the previous pages. Notice the importance of the fencing poles in the composition, giving the feeling of perspective in an otherwise very small canvas. All the finishing detail was completed with a sable size 0 brush. Painting any subject from different angles is often very inspirational. Monet would often paint the same subject at different times of the day showing the subtlety of colour changes and tone that occur in a two-hour period.

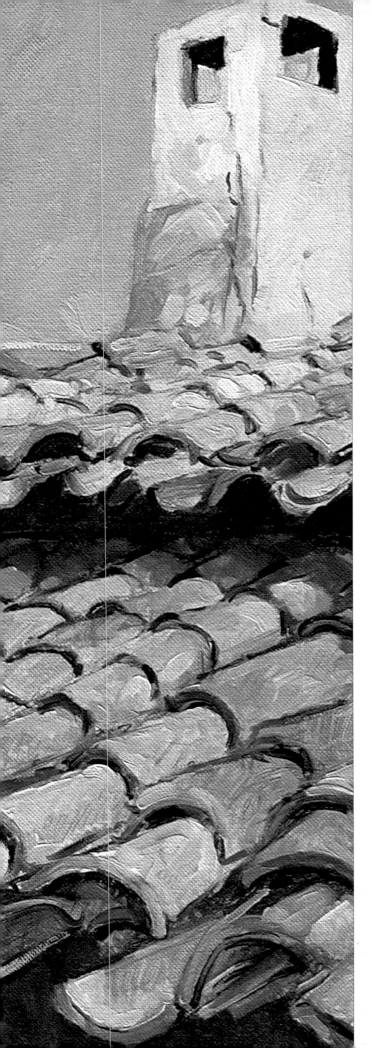

Landscapes could incorporate anything from simple views to panoramic seascapes - any view, in fact, that does not contain too much figurative work. If you do want to paint landscapes, try and avoid large vistas with lots of detail, unless you are prepared to spend a lot of time working out perspective.

The fun starts when painting outdoors. You have to put up with bad weather, poor light and people's comments, along with the inevitable painting by numbers jokes, so it is not for the faint-hearted. Proficiency is a great help, and using an old paintbox and wearing a dirty smock will give you a professional air, but unfortunately when you first start, with fresh paints and brushes, you will look like a beginner.

In this section I show you how to capture landscapes quickly using wet-into-wet techniques. Two demonstrations, one a seascape and one a winter scene, show what can be captured on canvas in a few hours. Good luck, and enjoy one of the greatest thrills of life – mastering landscape painting.

LANDSCAPES

Spanish Tiles
740 x 500mm (29 x 19¾in)

6 Hours

The colours and shapes of roof tiles make them irresistible subject matter. This painting relies on strong tonal content, the dark shadows under the tiles describing their shape, so I painted it in strong sunlight.

Sunlit Bay

4 Hours

I have chosen a painting that is simple in its construction and deliberately painted it large so that you can see some of the techniques magnified. This seascape is a few miles away from my home in southern Spain. It was a perfect day in early March, with no wind to disturb the easel. This is one of my favourite beaches and a good subject, with its beautiful cliffs and rock formations. This subject is a good one if you want to paint quickly, because of the simplicity of the elements. There are no buildings to worry about, there is nothing particularly happening on the beach and the sea is calm. Therefore you do not need to spend hours capturing detail.

You will need

Canvas board, 1180 x 900mm
 (46 x 35in)
Brushes:
 Hog filbert size 8 (large)
 Round fine hog size 2 (small)
Masking tape
Rope
Roller

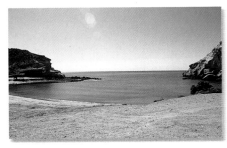

Colours

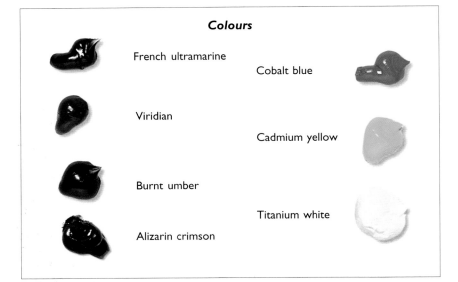

French ultramarine

Cobalt blue

Viridian

Cadmium yellow

Burnt umber

Titanium white

Alizarin crimson

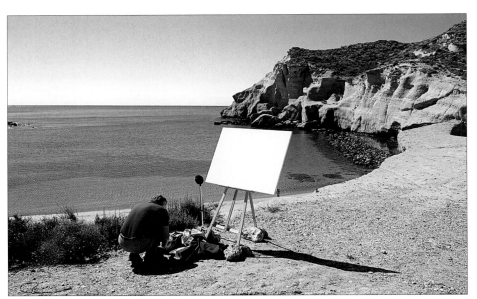

The view of the beach on the day I painted it from life. This beach is a wonderful subject. It is a favourite with the local people and it is amazingly peaceful during the first few months of the year. First of all, when painting a scene like this, choose your viewpoint. I was particularly interested in the background cliffs shown in this photograph, and the beach details which were only visible from where I was standing on the day.

Tip

It is important to have an organised paint box, so that you know where your colours are. This sounds all very well, but for me chaos reigns as soon as I start to paint! As you can see in the demonstration, my smock is covered in paint, and the tops of tubes are left off until the end of the session. The rope is there to tie the easel to a rock if the wind gets up.

1. Prepare your materials. Because of the large area to be painted, I have mixed sufficient colour on trays beforehand: a mix of cobalt blue and titanium white for the sea, a mix of French ultramarine and titanium white for the sky, and cadmium yellow and titanium white for the cliffs and foreground. I will be using a roller for speed, but I could have used a large brush instead.

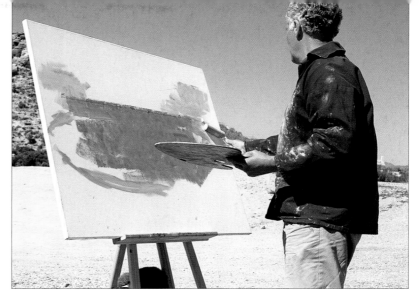

2. Lay a strip of masking tape across the canvas to indicate the line between the sky and sea. This is a simple trick to get the horizon line straight before starting. The tape will not stick over wet paint, so this has to be done first. It means that you can paint up to the line and over it without effort, leaving a perfect sky area once it has been removed.

3. Start the work by reducing areas down to their simplest shapes. In reality, the two cliffs on either side of the bay are quite far apart, but I have decided to paint them closer together in order to make a better composition.

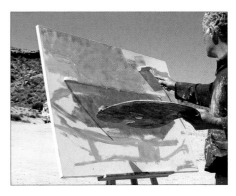

5. Paint on the sky using the roller. You can use vertical, horizontal and diagonal movements to block in large areas.

4. The light and shadows will be changing constantly, so keep looking at what you are painting as you quickly lay in your initial colours. Remove the masking tape when the sea has been blocked in and move it down slightly so the top rests on the sea level. This will enable you to finish a straight horizon line.

Tip

The sun is moving quickly and tonal areas are changing all the time. The wet-into-wet technique is ideal in these conditions because it is both fast and effective. Remember that whatever is in shade now could well be in full sunlight in a few hours, changing the tones completely.

6. You are now ready to start building up the colours.

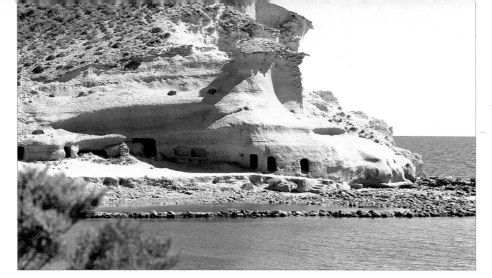

Detail of the sandstone cliffs

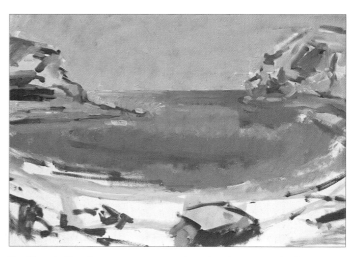

Tip
Simplify your tonal areas. The sandstone cliffs are peppered with grassy tussocks and prehistoric caves. At this stage you do not need to add any detail.

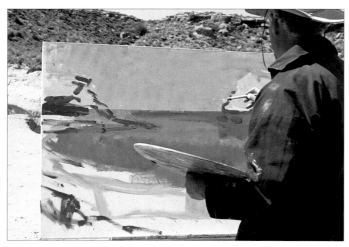

7. This stage will take you longer – adding and defining the shapes. It is not necessary to think about tone yet, but rather simply placing the largest areas. Use a mixture of French ultramarine and burnt umber. I use this mixture as a drawing pigment because it shows up well.

8. After half an hour, you can see that the drawing is far from detailed. Nothing has been developed, but everything is now placed in the composition. Tones have been deepened in the sea and the foreground rocks have been defined.

9. Continue by drawing in the shapes. Rather than working on the canvas as a whole, as before, pick an area and work on that in detail.

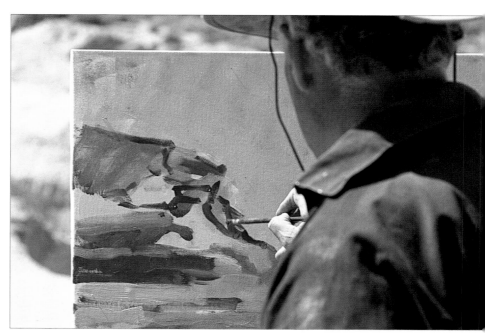

48

10. The painting is now taking shape. Keep looking at what is dark and what is light, and adding these simple shadows. The sea also has areas of darker tone; use viridian green mixed with French ultramarine, with a touch of alizarin crimson to soften the intensity of the colours.

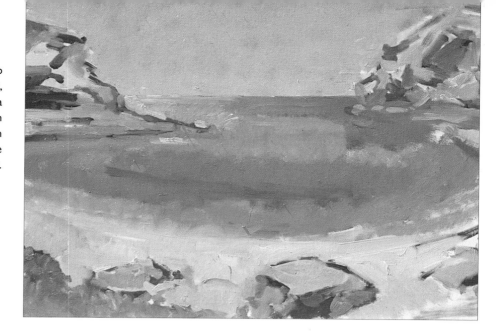

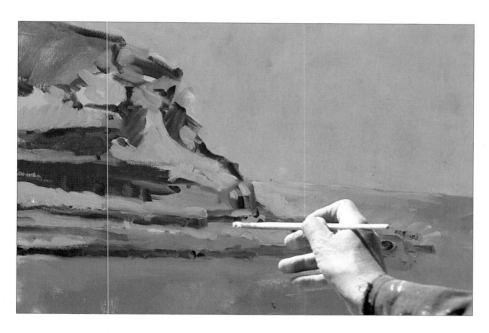

11. By adding similar colours to existing areas, you can develop details by technique rather than painstaking drawing. For example, here the colours of the rocks are given more interest by adding different tones of green-grey. The more you do this, the better the results.

12. The next stage can be achieved by the application of pure white added to existing areas. This will combine on the canvas with the other colours to produce a lighter tone, enabling you to emphasise the tonal structure more without spending time remixing colours.

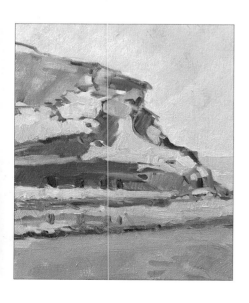

13. This white paint can also be used to define the wave areas on the beach.

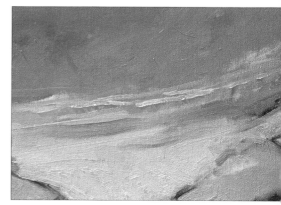

49

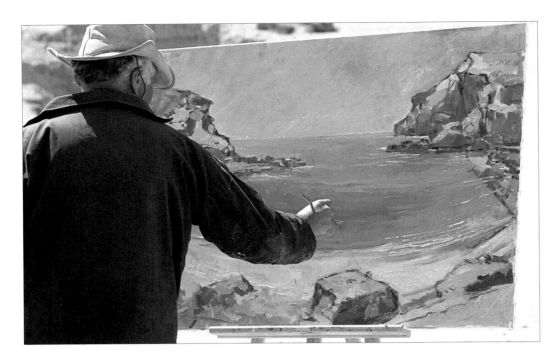

14. In this demonstration I have not used sable brushes for detail. This is because a round fine hog size 2 will give me all the detail I require on this large scale. To use a finer sable brush would mean further hours of painting.

The finished painting

1180 x 900mm (46 x 35in)

This painting took four hours to complete. For me, this is what instant oil painting is all about: production *en plein air* on a large scale. You have to have good weather for this (for comfort if nothing else), but there is nothing like the buzz of achievement if it works well.

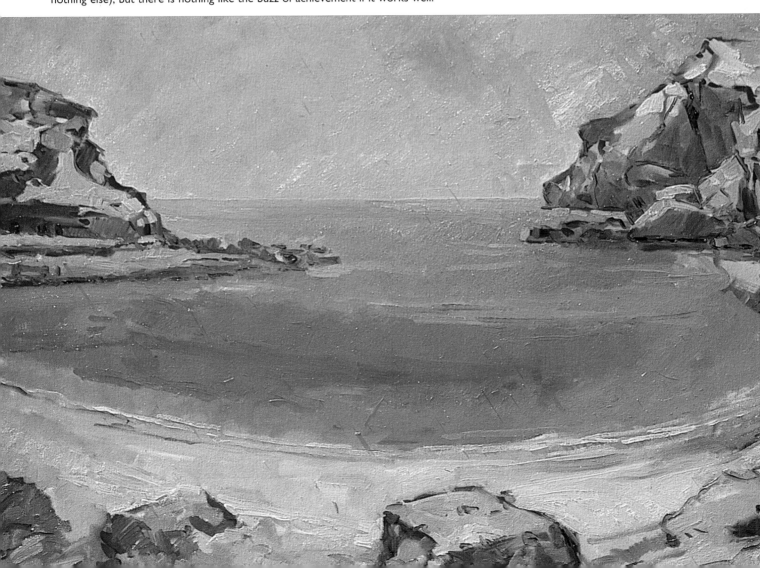

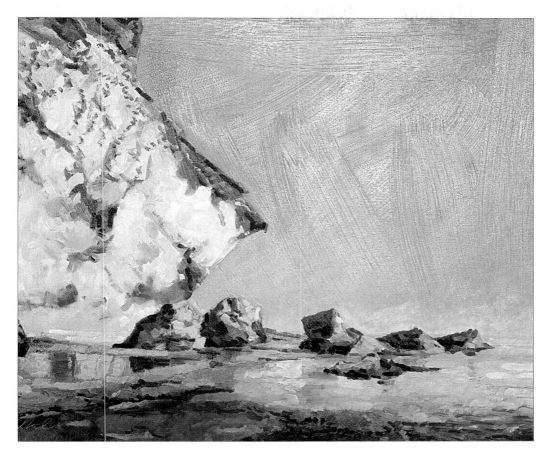

Top:
Fossil Cliffs
460 x 380mm (18 x 15in)

Bottom:
Shallow Rock Pools
460 x 380mm (18 x 15in)

3 Hours

These two paintings are of a bay only just around the corner from the beach opposite. They were executed at the same time using a back-to-back easel. This is an easel with two holding sides, which enables you to work on two canvases at the same time.

Apart from adding great stability to the frame, if you are faced with a good subject from both sides, you can paint two pictures simultaneously by simply moving your chair. This means that you only need to mix colours once, (although in a greater quantity) and it does mean a great saving in time.

So, it's all go with this idea, and it is a great 'keeping you on your toes' exercise, because you need to see and think faster to make it work.

First you need to paint the sky, so make a similar mix for both pictures. Then you start drawing in shapes and blocking in colour, as in the previous demonstration, before adding shadows, detail and so on, until completion. Paint similar areas at the same time, for example block in the beach on both sides before moving on to the cliff areas. I would put these two paintings in the instant sketching category.

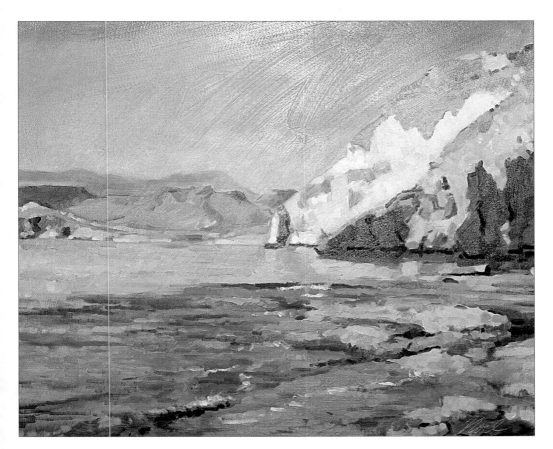

Winter Landscape

This is another example of landscape painting, but snow changes the tonal structures of a scene dramatically. All the usual rules apply in the painting, except that it is extremely difficult to work from life. I once tried it with conditions under six degrees, but painting is hardly an aerobic pastime and I just got too cold to continue, so painting from a photograph of snow is to be recommended.

You will need

Canvas board, 460 x 380mm
 (18 x 15in)
Brushes:
 Size 12 bristle (large)
 Short flat size 2 (small)
 Sable size 1 (detail)
Absorbent tissue paper
Linseed oil

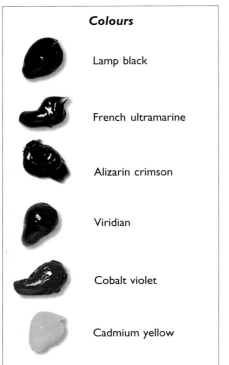

Colours

Lamp black

French ultramarine

Alizarin crimson

Viridian

Cobalt violet

Cadmium yellow

Titanium white

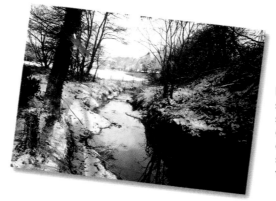

First, study your photograph to simplify the scene to its simplest shapes. Two dimensions into two dimensions are easier if you first choose a canvas or board that has the same proportions as the image you want to copy.

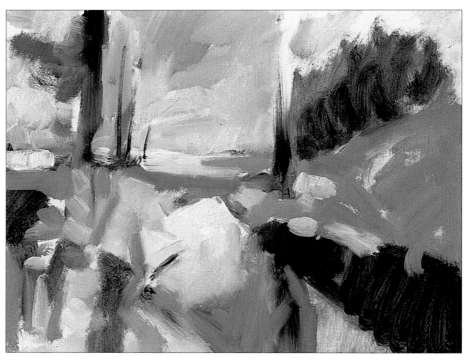

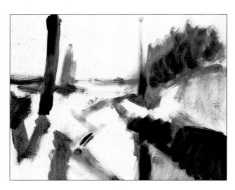

1. Initially, only the main areas are considered. The darkest areas are placed and these are painted without regard for realism. This is done with a mix of French ultramarine and small amounts of alizarin crimson and viridian.

2. The mid-tone areas have now been added to represent the shadow areas, leaving white areas of canvas as the white snow areas of the picture. This mid-tone is mainly titanium white added to the mix, giving it a lighter hue with more body. A little cadmium yellow mixed with titanium white has been added to give the first indications of sunlight.

3. Adding cobalt violet and cadmium red to the original snow mix gives a slightly warmer feel for darker tones. They can also be added by using a little lamp black. Use the small brush to paint these areas of detail in and around the mid-tone areas.

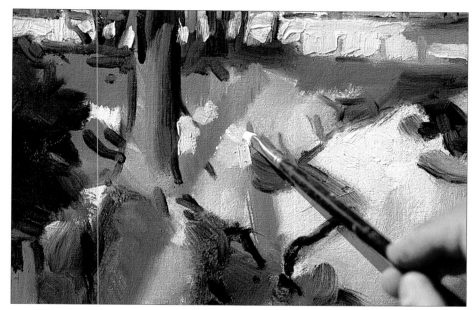

4. With all the preliminary drawing completed (left), including most of the tree shapes and twig details, the painting will now need more definition in the snow areas. Thick titanium white paint placed here will represent this best (below).

5. The thick white paint gives the snow life as well as redefining the sunlit areas. You will find that that underpainting will come through as you are adding this, but try to keep your brush clean by using tissue paper. I have also added more of the cadmium yellow and cobalt violet areas on and between the trees to represent further shadows.

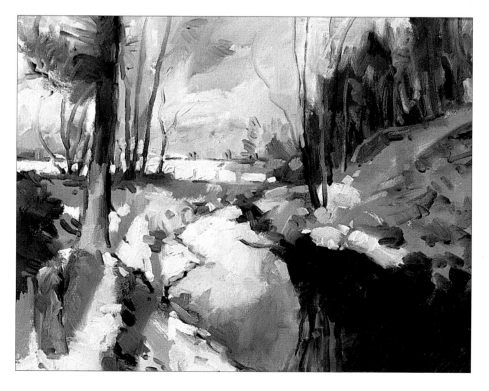

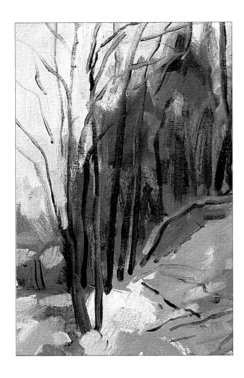

6. Add more French ultramarine and define the trees on the right. Let the sable brush do the work of the drawing. Starting from the main trunks of the trees, pull the paint towards the sky. The brush will glide evenly across the wet paint and produce flowing lines.

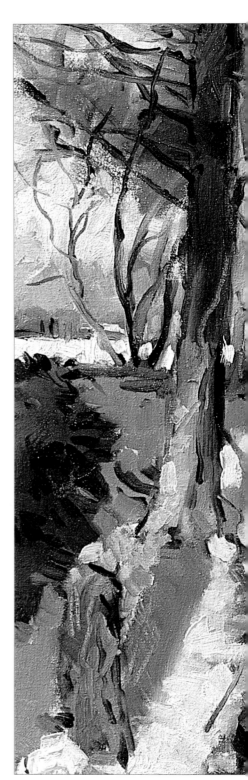

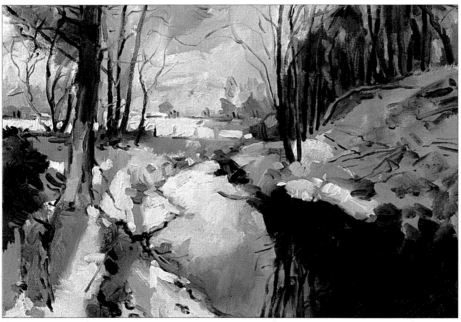

7. This intermediate stage has all the main structures in place and tonal values stated. All that remains to be done now is to carry on adding detail with a detail brush to complete the painting. This can take as long as you wish.

8. You can add as much or as little detail as you desire. Sometimes what you leave out can end up improving the finished painting.

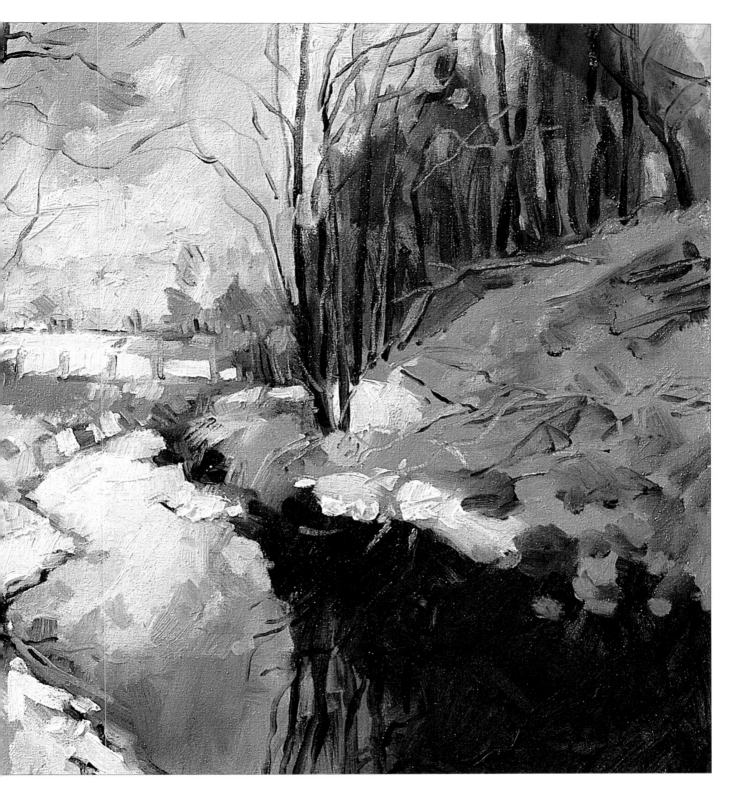

The finished painting

460 x 380mm (18 x 15in)

This picture shows the right balance between the blue-white areas of snow and the slightly warmer sunlit areas. It has very little detail, but a good strong tonal composition and it works all the better for it. Remember that snow has no colour but reflects tone and colours from its surroundings rather like water. Snow scenes have another great advantage in landscape painting: they generally have a very limited colour spectrum, i.e. blue, brown, green, etc. This means it can teach you a great deal about subtle colour mixing – landscapes are easier to understand without all the colours blazing out at you.

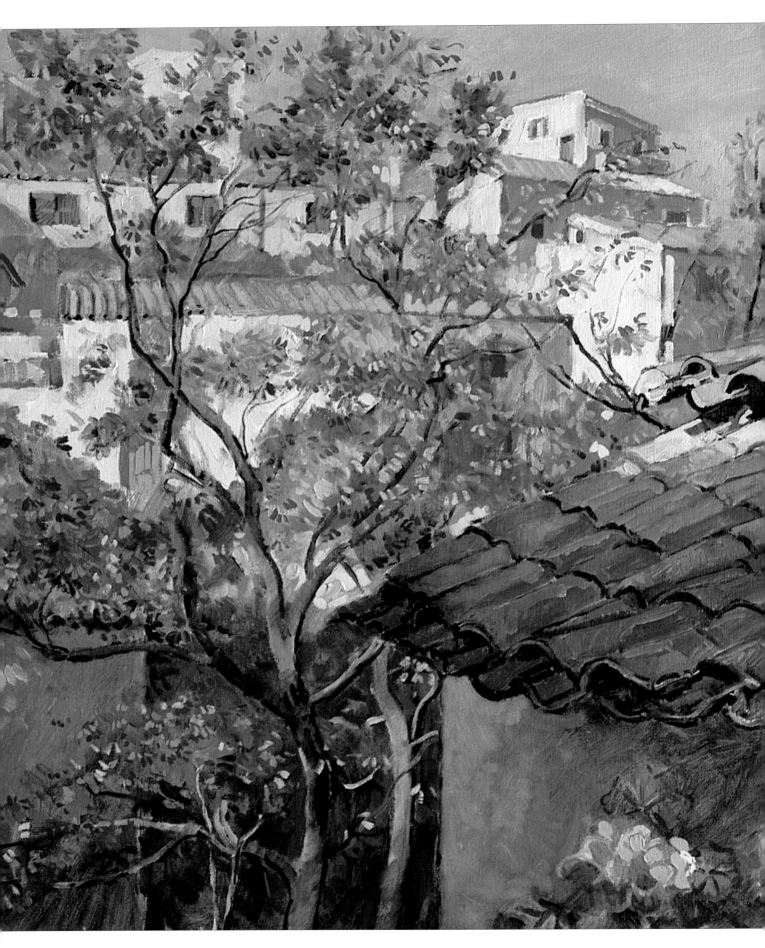

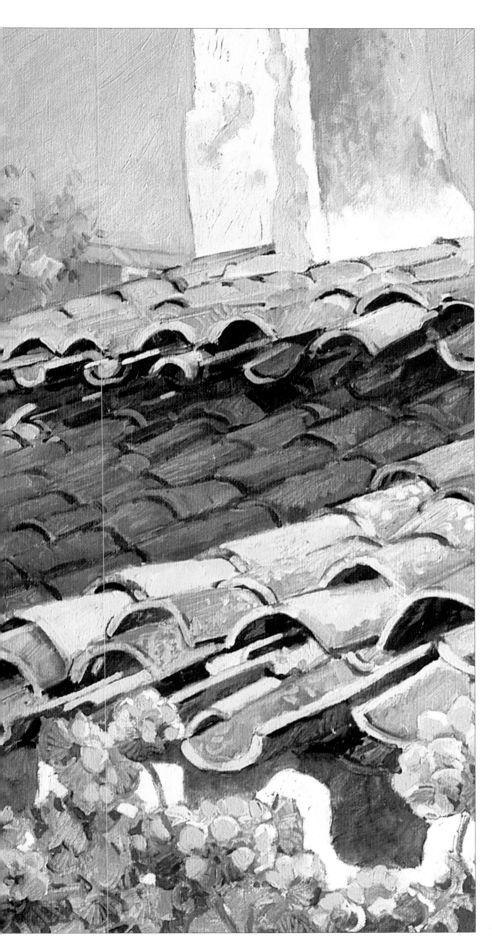

The Jacaranda Tree

730 x 550mm (28 x 19in)

4 Hours

I would like to say something about composition in relation to landscape work. Compare this picture to *Spanish Tiles* on pages 44–45. Composition is, of course, a matter of preference and the painting time available. These two paintings of the same subject inspired me to change the compositional content only slightly. This companion piece is a variation that completely changes the picture. This time the emphasis is one of added colour, with the tree and foreground flowers having more importance. Whichever you prefer is likely to be the one that held your interest to start with.

Like *Spanish Tiles*, this relies on strong tonal content. These paintings were completed with a year between them, so the tree had grown somewhat and the geraniums had been planted. This change in subject angle means that your painting becomes one of a series, helping you not only in painting techniques, but eliminating the need for a constant search for new subjects.

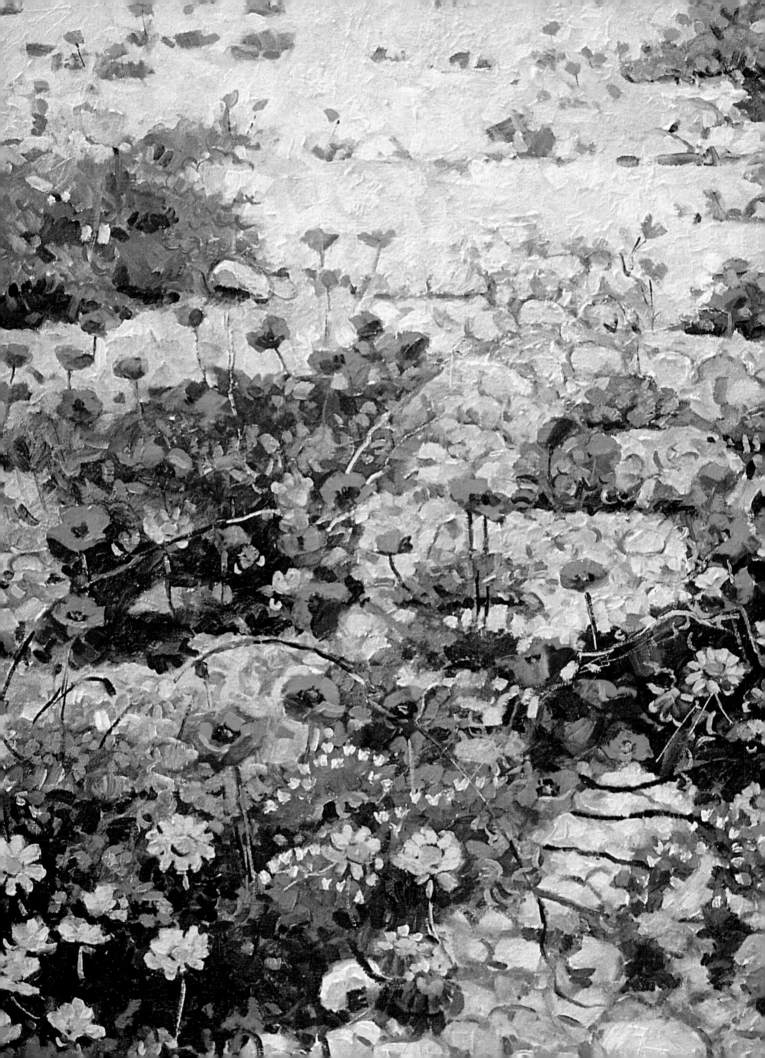

Flowers, unlike landscapes, can be painted in the studio without the worry of changing light. They have the added advantage that they do not require too much perspective, unlike still life subjects. They can look realistic, even if the basic drawing is less than correct. Their variety of colour will always be an inspiration for the artist, as well as their shape.

This beach scene is typical of a landscape that has been given a greater importance by the use of flowers in the foreground. They are also useful because the colour red is dominant, giving the scene greater dimension. With such a variety of flowers to be copied on the spot, I worked with the general shapes against the scattering of stones and took photographs to be used in the studio later for greater detail.

Flowers in the Sun

900 x 500mm (35 x 20in)

4½ Hours

Flowers will always add a special something to any landscape because their shapes and colours often give a focal interest. The only difficulty in using them as a design feature is that you have to have a lot of information to do the flowers properly. It is no good to simply try to remember them and hope to make them look right. This picture was started *in situ* and several photographs of the various plants taken to give me all the detail I would wish for. Removing objects, such as stones and branches for use in the studio is a good idea, too.

Irises

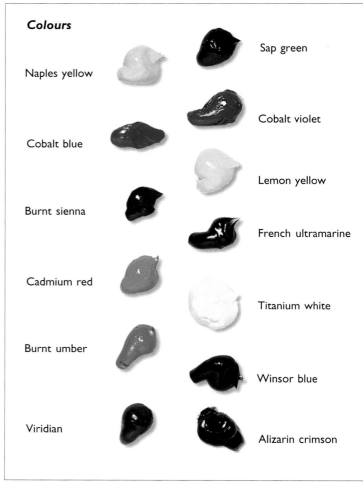

1½ Hours

Irises hold a personal interest for me, probably because Monet used them to such good effect in his famous garden, and also for their immediately recognisable shapes and strong colours. These irises have been transplanted from hundreds growing wild on my land in southern Spain. They make an ideal introduction to painting flowers growing in their natural habitat rather than arranged in a vase. The background becomes part of the picture although it is treated very simply, and perhaps slightly out of focus.

You will need

Canvas board, 325 x 405mm (13 x 16in)
Brushes:
 Filbert size 6 (large)
 Short flat size 2 (small)
 Sable size 1 (detail)
Masking tape
Linseed oil
Pencil
Turpentine

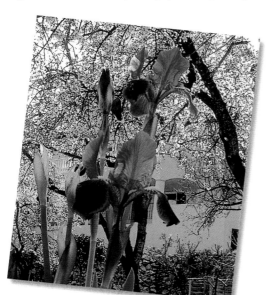

Colours

Naples yellow	Sap green
Cobalt blue	Cobalt violet
Burnt sienna	Lemon yellow
Cadmium red	French ultramarine
Burnt umber	Titanium white
Viridian	Winsor blue
	Alizarin crimson

1. Use a pencil to draw the main shapes quickly and simply. Mix linseed oil, turpentine and cobalt violet for a purple mix. Use this to block in the main flower petals with the large brush.

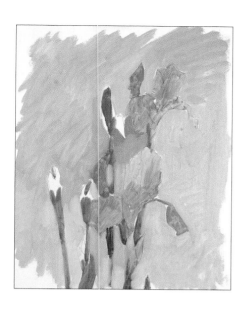

2. Mix sap green with plenty of turpentine until the mix is very thin, like a watercolour. Still using the large brush, paint in the stems of the irises. Mix alizarin crimson and titanium white into the green for a grey-pink colour, and use this to paint in the background. Vary the tone by adding lemon yellow to the mix near the bottom.

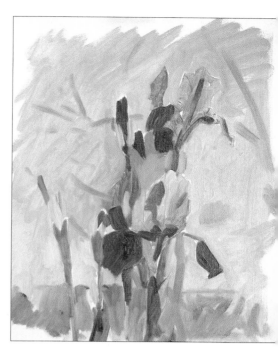

3. Add Winsor blue to the violet mix and add some shading to the petals. You can also shade the greens using this colour. Block in a rough indication of the background wall and trees, mixing the blue into the colours on the canvas.

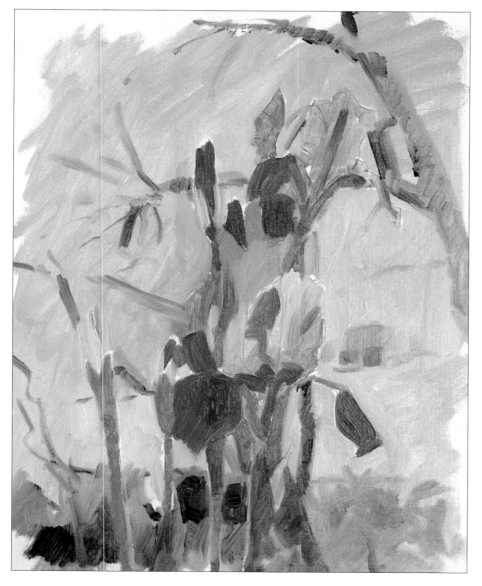

4. Mix viridian and lemon yellow together, and use the small brush to paint brighter tones into the greens and develop the wall in the background. Bring French ultramarine into the composition to shade the wall and develop the main branches in the background.

61

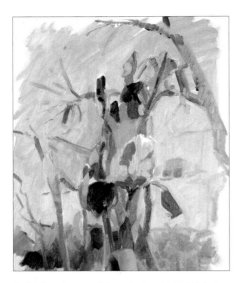 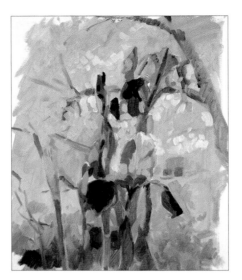 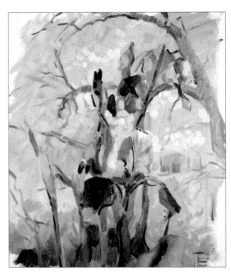

5. Using the small brush, begin highlighting the flower petals with a mix of titanium white and cadmium violet. Add Naples yellow to alter the hue and paint the pinky areas of the flowers, and use a mix of French ultramarine and alizarin crimson for the darker shades.

6. Use titanium white to knock the background back and give the foreground more importance to the overall painting. Paint in the sky showing through the blossom. I have used cobalt blue with burnt sienna and titanium white to dull the pink of the background. Add interest to the blossom with dabs of a cadmium red and titanium white mix.

7. Use the detail brush to reintroduce lost definition. Add cadmium red to the blossom mix for the highlights in the background.

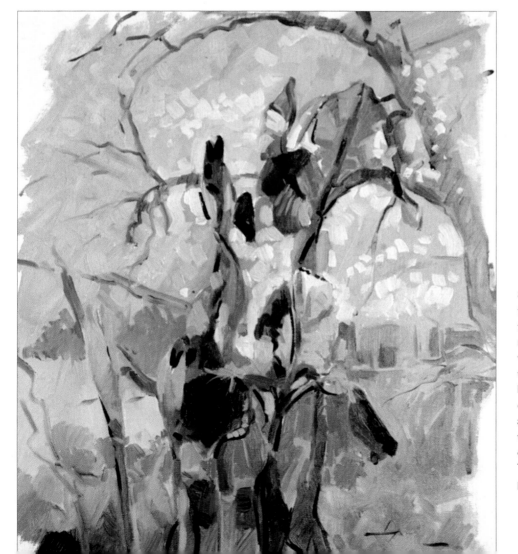

8. Still using the detail brush, tighten the picture by adding different tones to the main areas. Use the various mixes you have on the palette and vary them with titanium white. Mix titanium white, cadmium violet and burnt umber, and use this mix to deepen the colour of the background at the bottom. Mix cerulean blue and titanium white and paint in more areas of sky showing through the blossom. This helps balance the tone of the painting.

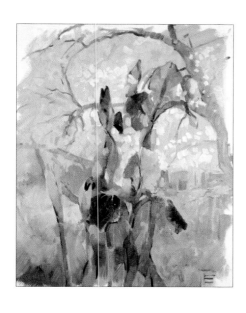

9. Soften down and blend the wet colours on the canvas using the large dry brush. Wipe the brush clean regularly to avoid muddying the paints.

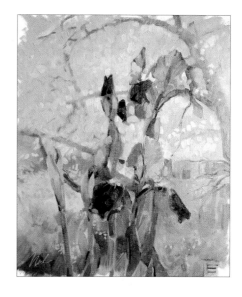

10. Once you have finished this, use short brush strokes with the small brush and add in some textures to the various elements with thick colour.

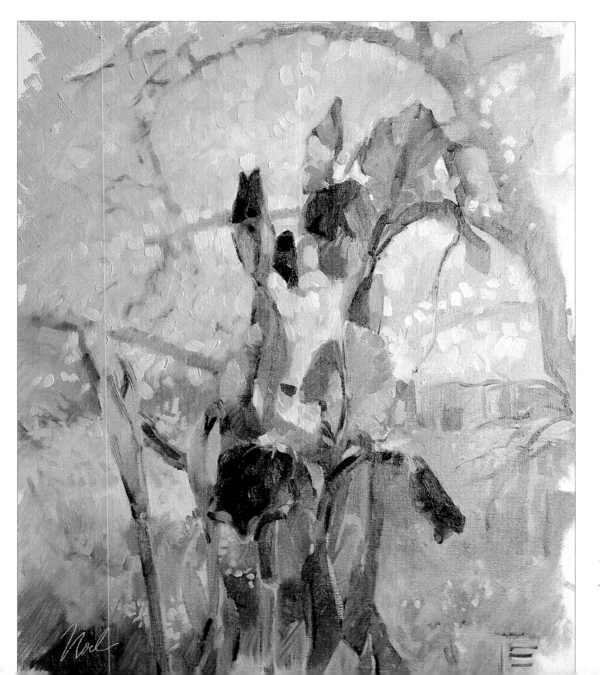

The finished painting
325 x 405mm (13 x 16in)

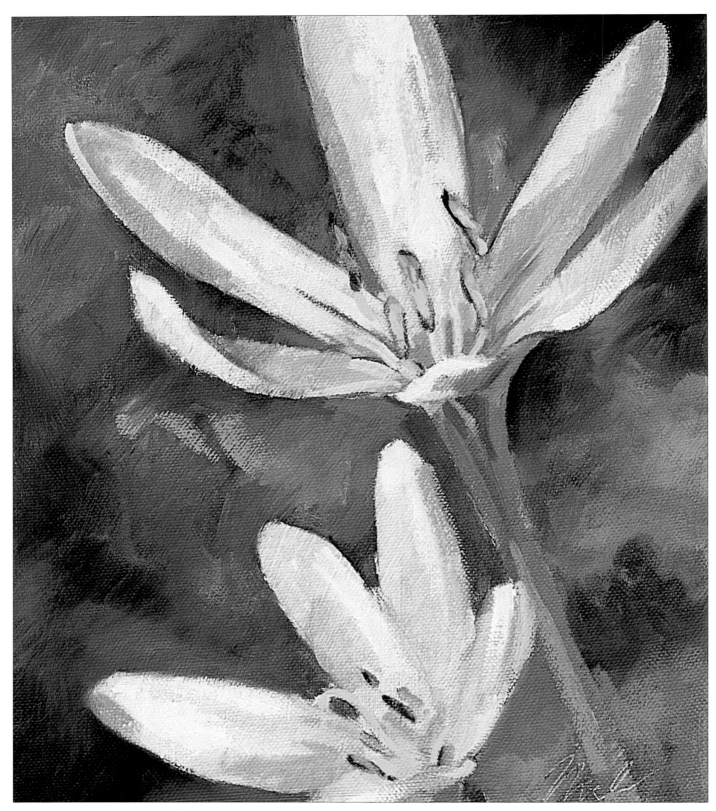

Crocuses

220 x 270mm (8½ x 10½in)

1 ½ Hours

This example is exactly what I have in mind when I talk about a simple composition, and demonstrates that even two blooms on their own can be extremely effective. Too much variety and colour in the flowers can detract from a painting and will also prolong its execution. The background also becomes important, and this is captured by the use of simple blurred areas worked over and blended with a clean dry brush.

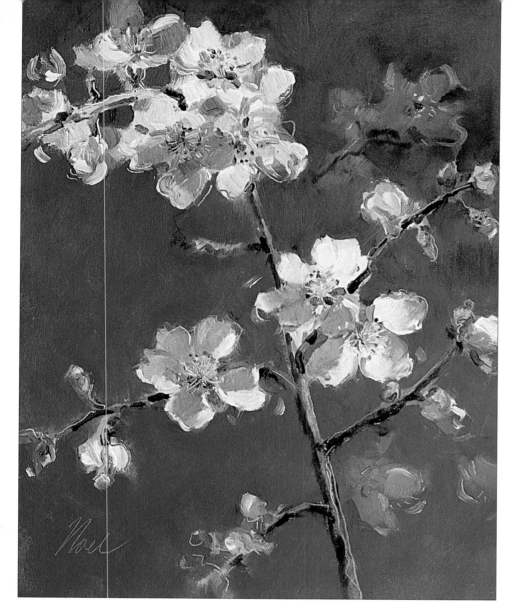

Almond Blossom

220 x 270mm (8½ x 10½in)

The almond blossom fills the whole canvas. The deep blue emphasises the white of the flowers and the dark sky brings out this contrast. This is a great tonal exercise.

Detail from:
Spanish Villa

750 x 650mm (30 x 26in)

This is a detail taken from the painting on pages 6–7. Notice that these flowers are explained with only the minimum of brushstrokes because the lighter-toned flower shapes stand out against the background. Too much detail here would not only take extra time, but you would also lose spontaneity and freshness.

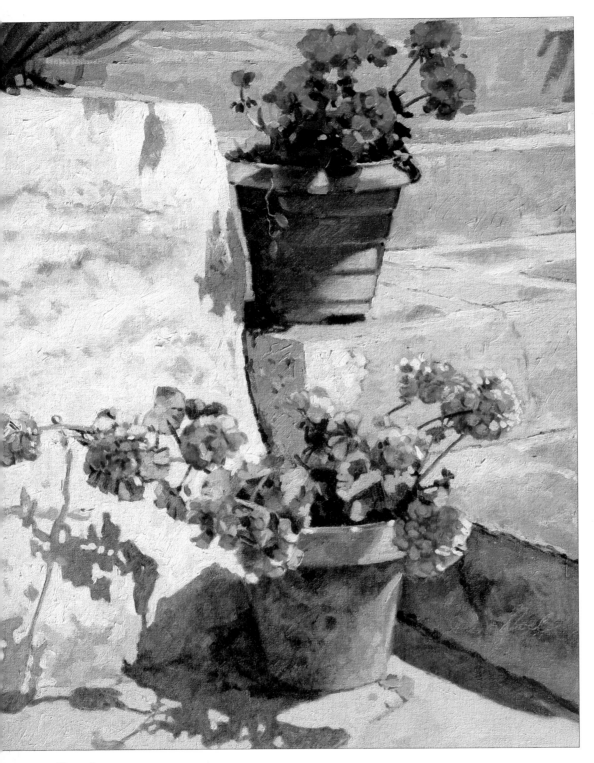

Opposite:
Sunlit Archway
230 x 300mm (9 x 12in)

3 Hours This is not a flower picture in the strict sense of the word, but the flowers are an important part of the composition. In fact, if you take them out, the picture would not have the same impact or balance.

The shadow of the plant and its container links with the dark tones of the archway. The red of the geraniums adds a further dimension to the depth in the picture with their intense colour.

Geraniums

320 x 410mm (12½ x 16in)

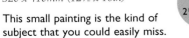

2½ Hours

This small painting is the kind of subject that you could easily miss. When you are surrounded by images, the obvious sometimes becomes secondary. I failed at first to see this picture, until I took a photograph of the surrounding area and saw for the first time how delightful these two plants were. I went back the next day and produced this picture on the spot, taking particular care to make the shadow area an important part of the composition. To me, this is an exciting flower composition: it is not just the same old boring plant in a vase, but it is a painting with strength and tonal structure.

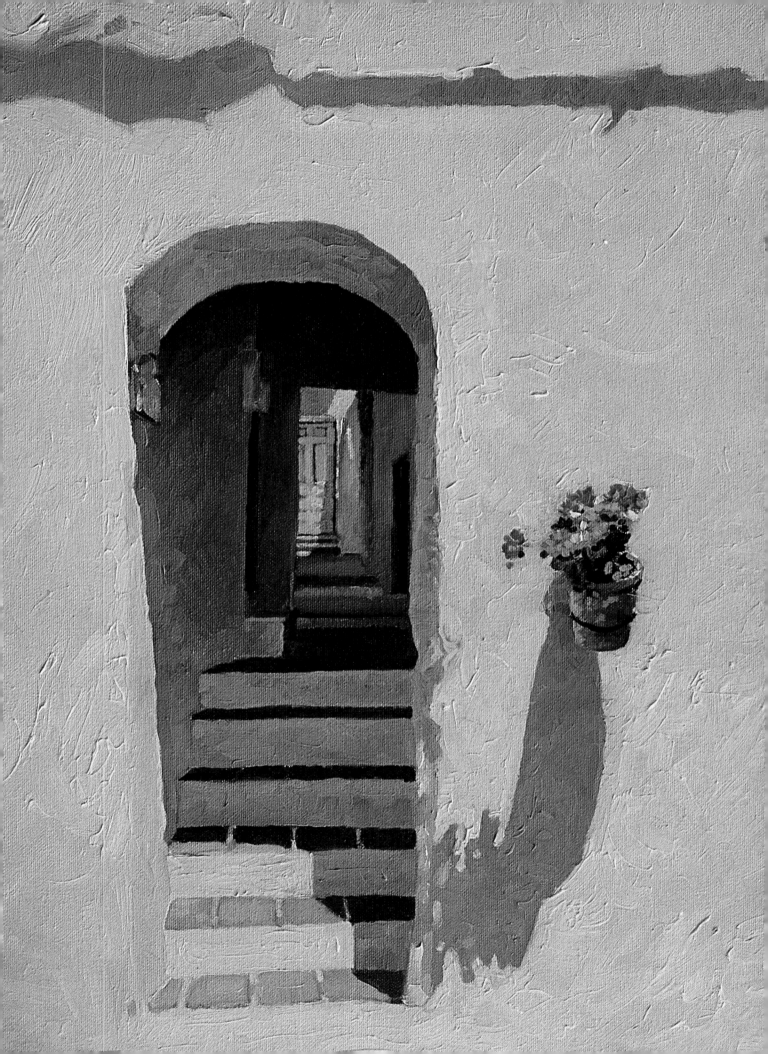

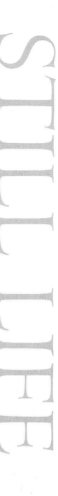

Almost anything that does not move can be placed into a still life painting. With a considered use of the spotlight it can be painted in the comfort of the studio, and started and stopped at any time without change of shadow.

I have purposely included fruit in this section, because like flowers it can be painted without great detail and still remain recognisable.

It is less complicated (though not necessarily easier) to produce a still life than some other forms of painting. This is because once the object has been placed, there is no movement, and therefore, unlike landscapes, animals and plants, the reference will always be the same. So it is up to the artist to choose objects that relate well to one another in subject, or in colour, or in shape; and place them in an inspirational way and with good lighting, so that the final painting will have a strong impact.

Basket of Tomatoes

8 Hours

500 x 400mm (19½ x 16in)

Strictly speaking, this illustration is not an instant painting because it took a good day in its making. I have included it to show the development from a few tomatoes into a full still life group. The basket is the frame of the composition, and the different colours of the fruit together with a good lighting source make for an excellent finished picture – one that I really enjoyed painting.

HELPFUL HINTS

The following hints will help you with your choice of subject matter for still life paintings.

- Choose objects that have some connection with each other, either in colour or nature. For example, the picture opposite has a selection of squash shapes.

- Limit the number of objects to avoid complication. This will not only increase the speed of your painting, but it will make for a better image.

- Fill the canvas with the subject and not background.

- Limit the colours of the objects and the background. Too many can be confusing. Simple choices using related colours give better results, as below.

- Be aware of the shapes between the objects. I show this on the opposite page.

- Do not include heavily decorated objects, such as cut glass. This removes time spent on detail.

- Light objects from one side with a spotlight. This will give good shadows and a greater three-dimensional image.

- Paint the subject from a close up angle – as near as you can get, eliminating the need to make up detail by being too far away.

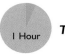

I Hour

The Two Pomegranates
250 x 200mm (10 x 8in)

The pomegranate has a simple round shape and, cut in half, is extremely interesting to paint. In this composition I have used a strong side light to give me my shadows. Similar hues are used for the pomegranates and the background, giving colour unity. This idea can be tried with any fruit such as oranges, apples, tomatoes etc. and it will help to develop an understanding of three dimensions and tone.

LOOKING AT SHAPES BETWEEN OBJECTS

Seeing objects by spatial shapes was the vogue in my art school days. Although this left me with less than a complete understanding of the subject, it is a valuable way of looking at things. You are no longer concerned with whether your subject is a landscape, portrait or still life, you are only aware of the shapes that objects make in between each other. If you are painting several objects, as in the picture below, it is important to look at the spaces around them and the way they relate to each other. Try squinting your eyes at this illustration and looking at the blue areas. It is the shapes in between that need to be drawn correctly, and not necessarily the objects.

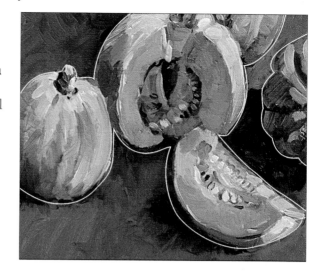

Squashes

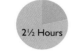 2½ Hours

300 x 250mm (12 x 10in)

In the pomegranate picture opposite, I limited the colours to create a feeling of unity. Here, I have used contrasting colours. Notice how the red squash is enhanced by the use of blue in the background, the colour opposite it on the colour wheel.

Painting Metal

 2½ Hours

One of my students brought a pewter jug to a class to add to a still life composition. He also brought pewter spray paint to use in the picture – an obvious mistake: a spray will only give a completely flat pigment areas, and this will look very unlike what you need to achieve to get realism. Metal reflects its surroundings, just like glass. It is the painting of these reflections that gives us our object. In this demonstration I have chosen three objects that are made from very different materials – copper, pewter and brass.

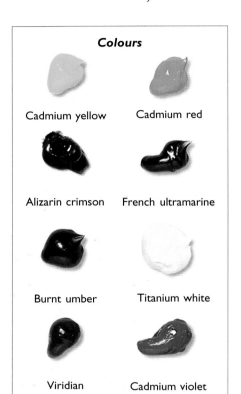

Colours

Cadmium yellow

Cadmium red

Alizarin crimson

French ultramarine

Burnt umber

Titanium white

Viridian

Cadmium violet

Useful mixes

Brass bowl
Alizarin crimson, cadmium yellow and titanium white.

Copper plate
Cadmium yellow, cadmium scarlet and cobalt violet.

Pewter tankard
Alizarin crimson, French ultramarine and a touch of titanium white.

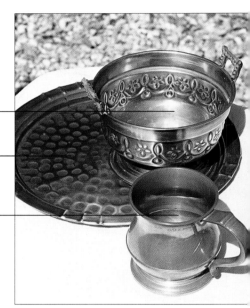

This arrangement has been lit from one side to bring out the dark tones and highlights of the metal objects.

1. Using a small, dry brush, lightly paint in the outlines of the plate, tankard and bowl. Fill the canvas with the subject and not the background.

Tip

When you paint the initial outlines, use a dry brush with only a touch of white spirit and very little paint.

2. Use the suggested mixes to paint in the main shapes with flat colour. Squint your eyes to evaluate the darker areas, add small amounts of French ultramarine to your mixes and add the darker colours to the relevant areas.

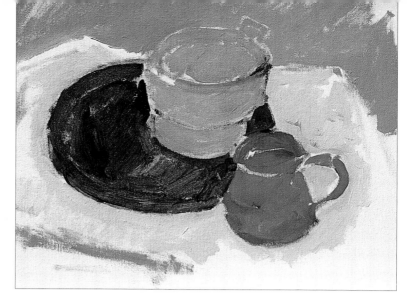

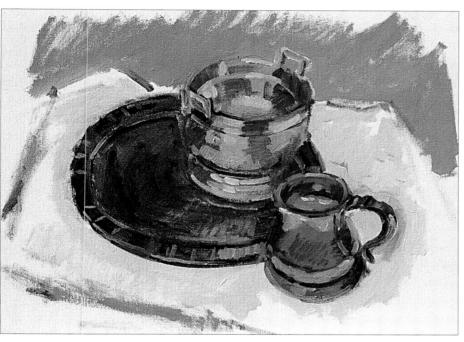

3. Highlights should be added using pure white. Darker tones should be added using a mix of alizarin crimson and French ultramarine. This will blend with the wet underpainting. Notice that the orange hues on the brass bowl are reflected from the copper tray. Small amounts of cadmium red and cadmium yellow will help you with this.

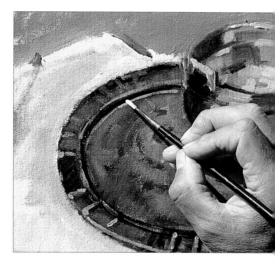

4. Continue adding colour by observing what you see. White highlights are added to the copper plate to represent reflected light.

Tip

Keep the tonal areas simple and when you are painting a still life like this, study the reflected colours, light and shade from each surface. It is this that gives the impression of metallic surfaces.

5. Keep correcting and adding to the colours: oranges, browns, reds and greens. At this stage, you can redefine and adjust the shapes of the objects by repainting the background.

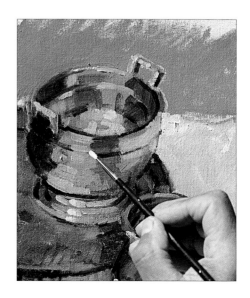

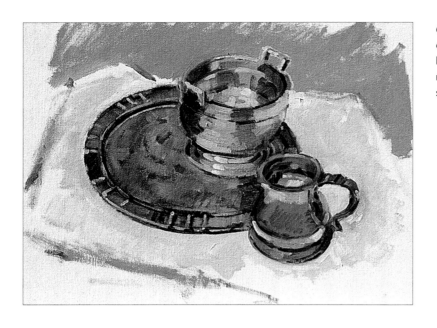

6. Using a thicker version of the copper mix, paint the copper reflections on the tankard and bowl, then the brass reflections on the copper plate using a thick brass mix. Blend cadmium violet into the copper mix for the shades of the plate.

Tip
When working on fine detail with a sable brush, it is useful to steady your hand by using a mahlstick.

The finished painting

410 x 330mm (16 x 13in)

The painting was allowed to dry for two hours, then the colours were blended with a large dry brush to create a softer image. Notice that the original brass bowl was embossed. I felt this was an unnecessary detail, taking time and adding little to the painting, so it was not included.

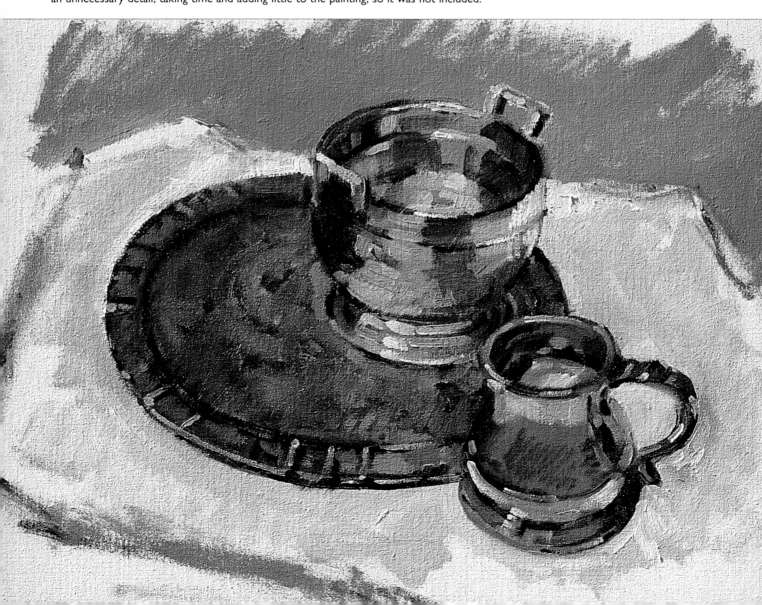

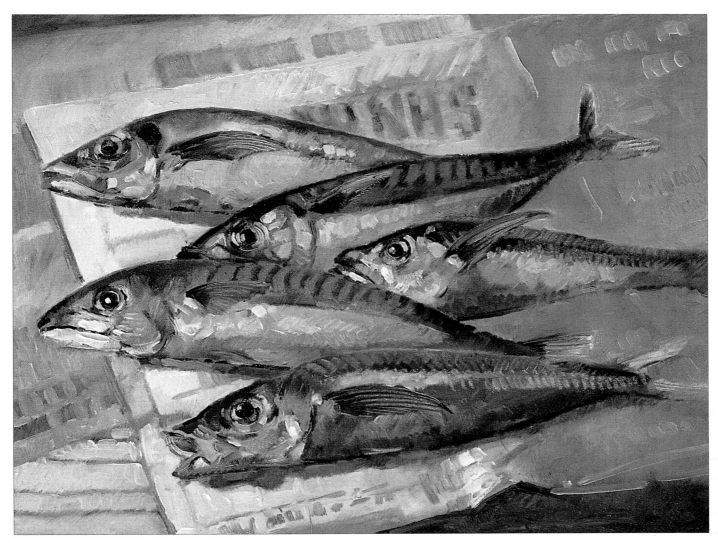

Fresh Catch

410 x 330mm (16 x 13in)

2½ Hours

It is not just metallic objects that have reflected colour. The pigments I have used in these fish are mainly blues and purples, with a small amount of viridian. These colours, mixed with titanium white, give an overall impression of silver. If the background were a different colour, i.e. red or yellow, the fish would reflect more of these colours, and they would have to be added to the palette. In the detail below, I show a liberal use of white which is painted thickly over existing colour to emphasise the tonal structure and to represent shine on the fish scales.

Painting Glass

1 Hour

Painting glass sounds much more difficult than it really is. At first it seems daunting to reproduce clear glass, but in reality it has a colour structure taken from the surrounding areas, and tone from its thickness.

This demonstration shows that a simple glass tumbler can be an interesting and challenging subject. Remember to constantly squint your eyes in order to see the differences in tone. It will nearly always be a lot darker than you first thought and if you do not represent these dark tones strongly, everything will look flat in the finished picture. So, if you can differentiate between the almost black shadows and the pure white light reflections, the rest of the glass will only be a matter of sorting out the mid-tones.

You will need

Canvas board, 220 x 270mm
(8 x 11in)
Brushes:
 Filbert size 6 (large)
 Small flat size 2 (small)
 Sable size 1 (detail)
Linseed oil

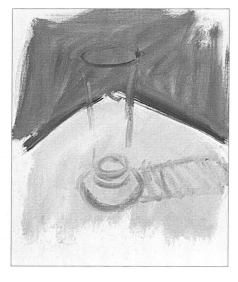

1. Using the large brush, block in the background colours using mixes of French ultramarine and titanium white. Loosely draw in the glass and its faint shadow.

Colours

Cerulean blue

French ultramarine

Titanium white

Alizarin crimson

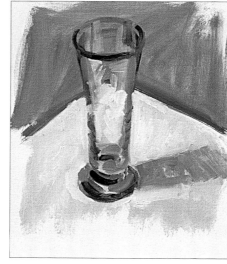

2. Reinforce the outlines and brush in the darker areas of the shadow. Paint in the main light areas on the glass, working over the background colours.

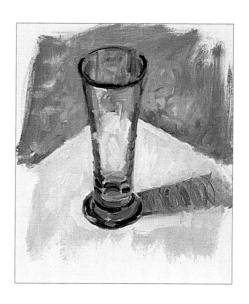

Tip

Glass is transparent and it reflects the colours surrounding it. The thicker the glass, the more contrast will be seen between the colours.

3. Change to the small brush, and using bluey-grey mixes, start building up the darker tones around the base of the glass and in the shadow. Add a touch of alizarin crimson to work warmer tones into the background with random brush strokes.

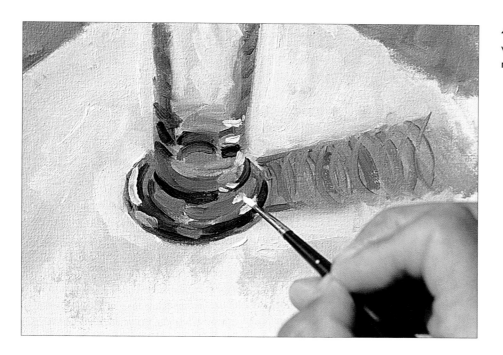

4. Using the detail brush and thick titanium white paint, add the highlights. These will make the glass sparkle and shine.

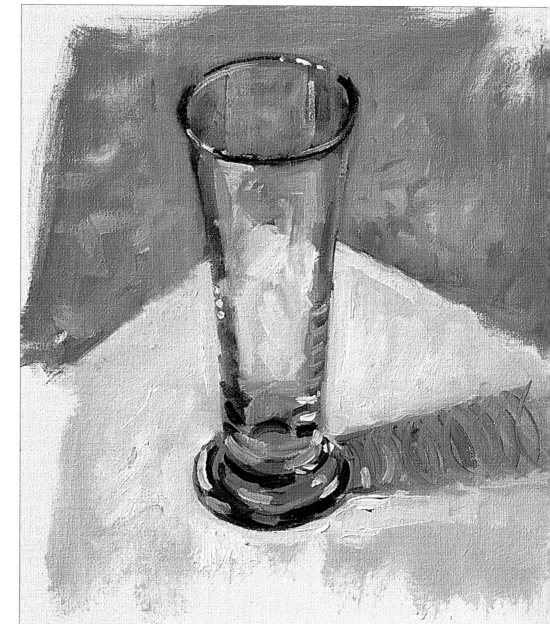

The finished painting

220 x 270mm (8 x 11in)

Although the glass looks like it has been painted using black, the dark areas were created by mixing French ultramarine and alizarin crimson together to create a dark but not dead-looking tone.

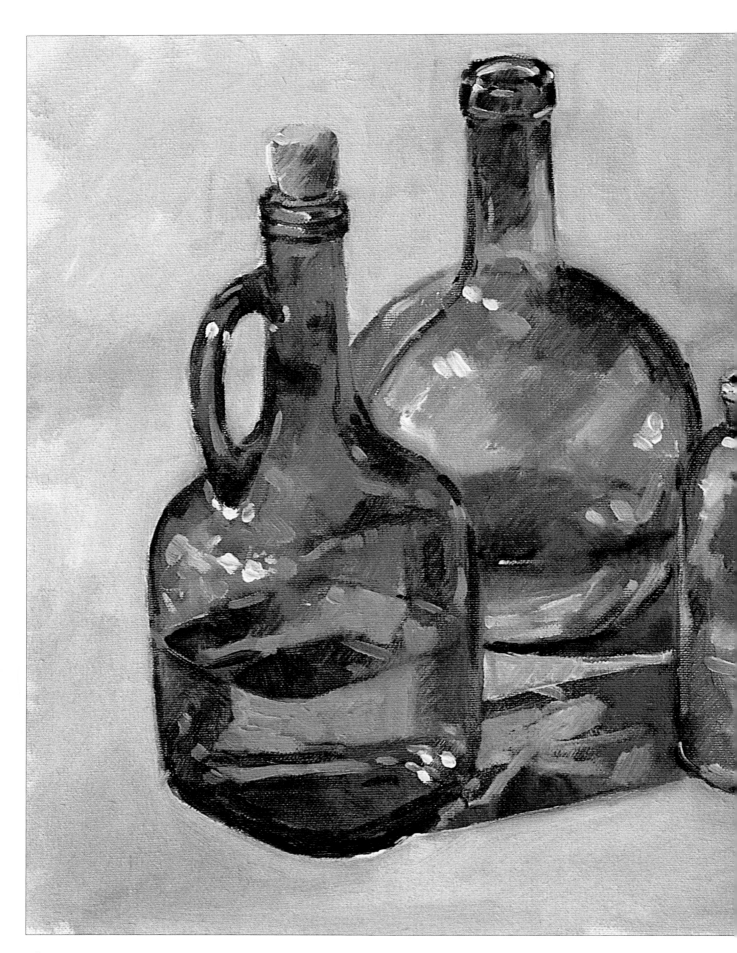

Bottles in the Sunlight

3 Hours

480 x 380mm (19 x 15in)

A still life, with differently shaped and coloured glass bottles, shows how exciting this subject can be. The added interest is the use of strong sunlight to cast the coloured shadows. This effect can easily be copied by the use of a strong spotlight in the studio. Only one of these glass units had any real colour – green, but the others reflected this and further colours around the studio. Again, it is the degree of light and dark that determines the form of the glass. Take time to study the tonal values by squinting your eyes.

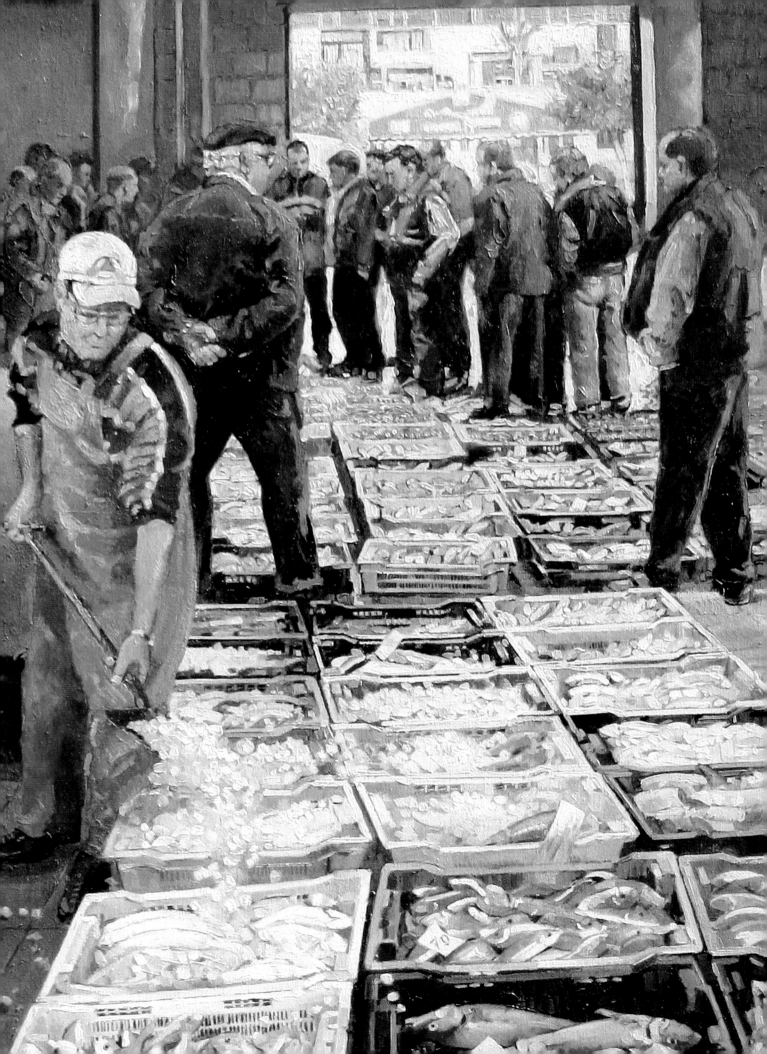

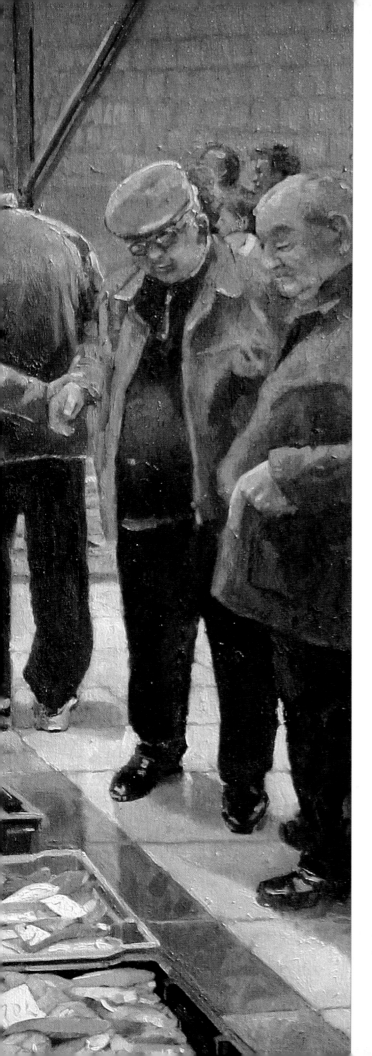

Figures can be an important part of our picture making, but they can also show up weaknesses if they are poorly executed; so it is very important that figures are drawn from as much information as possible.

Sketchbooks were the order of the day at my art school and they can be very useful. Today, the best 'sketchbook' must be the camera and with this digital recorder and a printer you can have all the information you need instantly. If I require figures in a landscape, all I do is to take as many shots as possible and arrange them together, as in this painting where I used five different photos to make the image.

Detail from:

The Fish Market, Southern Almeria

1000mm x 1750mm (39 x 69in)

This painting took almost two weeks to complete and so can not really be regarded as an instant oil painting. However, this detail shows the importance of figures in a painting of a subject that would be less interesting without them. Although the figures take up the top half of the painting, they are of great importance to show scale. A knowledge of painting figures is therefore extremely important even in other sorts of painting such as landscapes.

Children in the Park

 2½ Hours

When painting figures quickly, it is essential not to include much detail. It is also important, if you want a fast result, not to paint features because it is impossible to paint faces quickly without getting involved with capturing the likeness and character of the subject.

There are a few tricks you can use when you want to include figures in a scene.

- Avoid too much detail in the faces and hands. Simplify them with a few marks rather than trying to reproduce features or fingers.

- Always use some kind of reference – photographs, sketches, etc. Never try to make figures up. You cannot simplify with a lack of knowledge.

- If you find your figures work with a few brush strokes, leave them alone and do not be tempted to fiddle.

- Too much detail may give greater importance to your figures than you would wish. You may find yourself looking at nothing else when the painting is finished.

- Consider painting back views; this will eliminate having to include too much detail.

- If you add figures, make sure that they are to scale, for it is very easy to make them too big or too small from unrelated reference material.

Here I demonstrate how to achieve a pleasing result with a simple composition of the back view of two children. The wet-in-wet technique can be used to great effect to capture the charm and intimacy of this scene.

You will need

Canvas board, 300 x 400mm
 (12 x 16in)
Brushes:
 Filbert size 6 (large)
 Small flat size 2 (small)
 Sable size 1 (detail)
Linseed oil

Colours

French ultramarine

Titanium white

Cobalt violet

Burnt umber

Cadmium red

Cobalt blue

Sap green

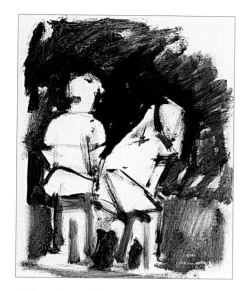

1. Start by quickly and lightly sketching in the outlines and clothes with the small brush and a mix of French ultramarine and burnt umber. Block in the surrounding dark area. Lay in the green grass below the figures using sap green and titanium white.

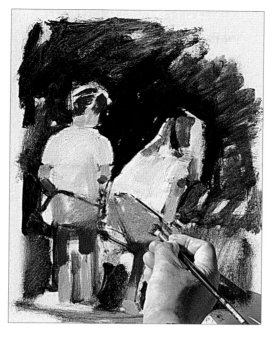

2. Using a mix of linseed oil and titanium white, paint in the light areas, rigorously working the paint into the canvas with random brush strokes. Add a touch of cadmium red and start painting in the flesh tones. Use burnt umber to establish the hair, then lay in the green areas on the clothes with a mix of sap green and titanium white.

3. Using the small brush and French ultramarine mixed with titanium white, add the shadow areas on the t-shirts and shorts. Work a darker blue tone into the hair and the t-shirts.

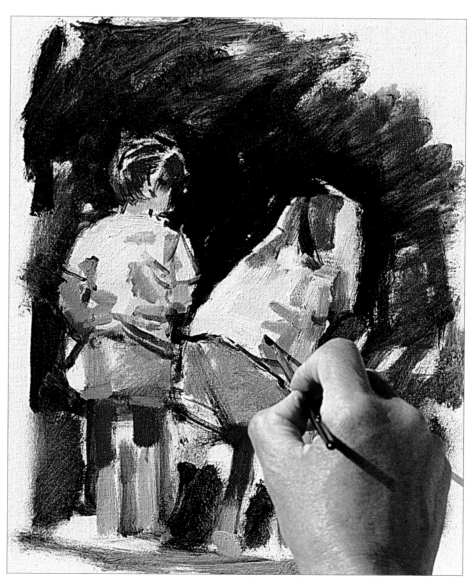

83

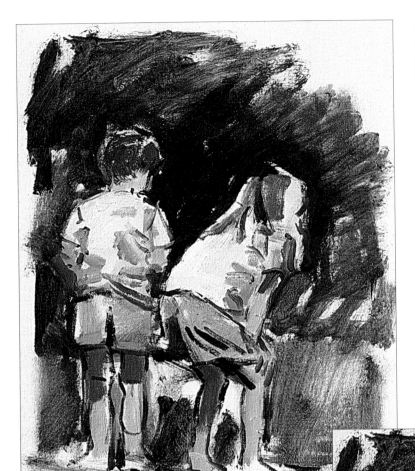

4. Carry on drawing detail into areas with a sable brush and French ultramarine mixed with cadmium red. This will give the shapes and structure which will determine where further areas of colour will be developed.

5. Build up the dark and light yellow tones in the children's hair. Do not mix the paint on the canvas too much, but lay the strokes down, following the fall of the hair. The skin areas need more form, so add more flesh tones, refining details and lightening areas. More detail needs to be added to the shorts, so mix green with a touch of white and paint in some folds, then add brown and yellow tones. Paint the lake using cobalt blue; the lighter blue tone will define the childen's legs, making them stand out against the background. To complete this stage, add the boy's shoes and socks using cobalt violet.

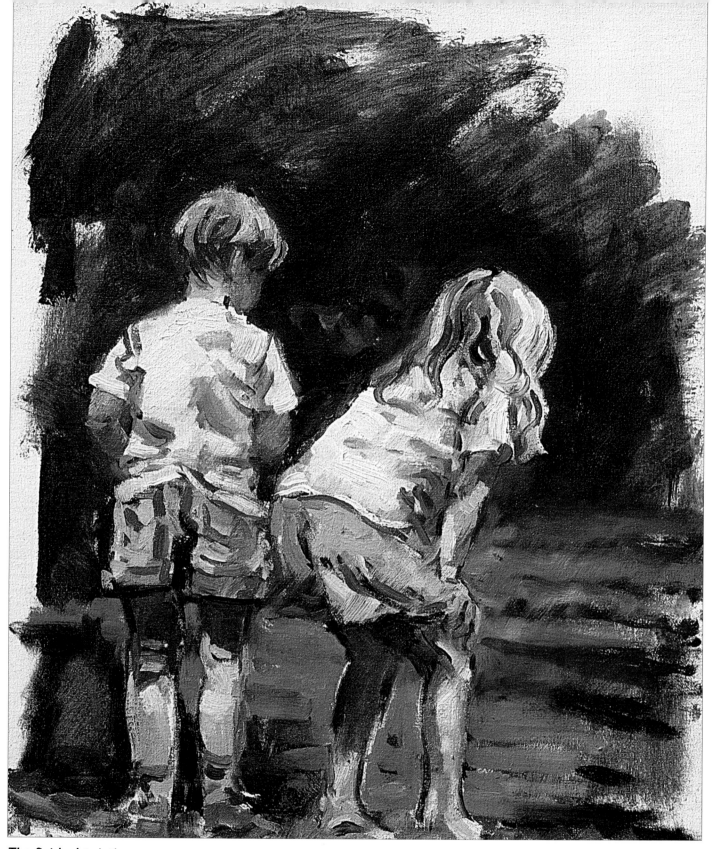

The finished painting

300 x 400mm (12 x 16in)

To complete the painting, dark blue is worked into the background around the children.
The shadows and dark areas are refined in the background and figures, then more colour
added to the water's reflections with dark blue and light blue, using horizontal
brushstrokes. Pure white highlights are mixed with the underpainting to create a feeling of
sunlight. Finally, the water is softened with gentle strokes of a dry brush.

Glamour Star Portrait

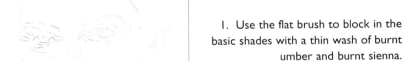

1½ Hours

This is an exercise in painting youthful skin from a magazine cover, showing helpful hints in how to get the tonal and colour structure correct. There is no magic colour for skin tones, even if a tube mix says 'skin hue'. Skin colours are a huge mixture of different tone values. Try copying colours from a photograph of yourself. I hope you find this useful, but it is only a starting point and you will want to add other colours as you become more experienced.

You will need

Canvas board, 300 x 400mm
 (12 x 16in)
Brushes:
 Filbert size 6 (large)
 1in masonry brush (flat)
 Round size 2 (small)
 Sable size 1 (detail)
 Fan fine hog size 8 (large fan)
Pencil

Colours

Burnt umber	Cadmium red
Naples yellow	Viridian
Winsor blue	French ultramarine
Burnt sienna	Lamp black
Titanium white	Lemon yellow
Cobalt violet	Alizarin crimson

An initial sketch is useful, allowing you to plan the painting in pencil before you apply any paint.

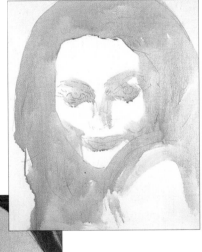

1. Use the flat brush to block in the basic shades with a thin wash of burnt umber and burnt sienna.

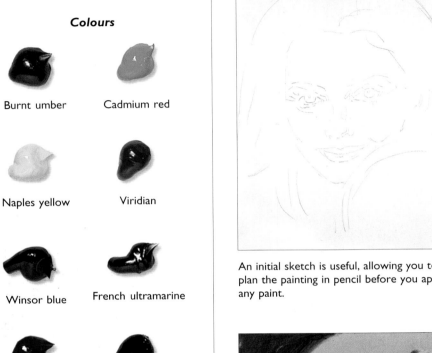

2. With the large brush and a mix of Naples yellow and titanium white, block in the light areas of skin. Add Winsor blue and cobalt violet to the mix for the background, then add cadmium red for darker areas on the face and hair.

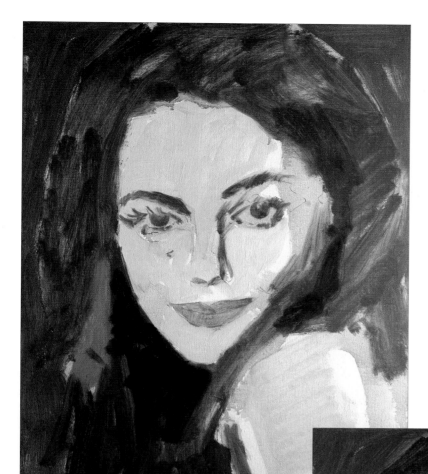

3. Mix cadmium red into the lips, using a mix thinned down with turpentine until it is a similar consistency to a watercolour. Vary the dark tones on the picture with some of this red. Mix burnt umber and burnt sienna and scrub this onto the hair and eyes, using a touch of cadmium red to give the colour some life. Use a tiny touch of lamp black for the deepest shades.

4. Use a wash of titanium white, cadmium red and lemon yellow to shade the skin. Add burnt umber and cobalt violet for the darkest parts, and a spot of viridian to prevent the red from making the flesh too vibrant and hot. Use the small brush to shade the lips with an alizarin crimson and cadmium red mix.

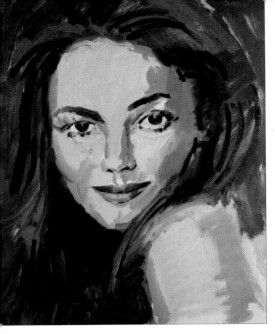

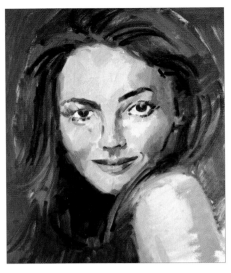

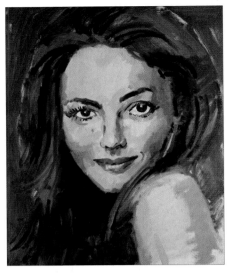

5. Add French ultramarine and viridian to the lip mix, and paint this dark grey on to the eyes, eyelashes and eyebrows, using the sable brush. Use the same mix to define the lips and hair. Use titanium white to paint the whites of the eyes, and blend white into the main areas to highlight.

6. Mix cadmium yellow, titanium white and a spot of cadmium violet for a different skin tone. Vary this by adding a touch of alizarin crimson. Dull this down by adding more alizarin crimson, burnt umber and Winsor blue.

7. Using the detail brush, work finer detail using the mixes from step 6. Concentrate on the areas around the lips and eyes, adding sharp highlights and adding mid-tones between the shades and highlights. Paint on the earring.

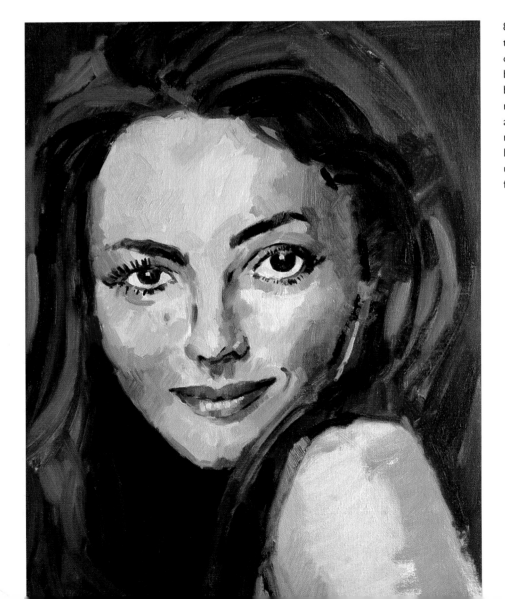

8. With the large brush, add light tones to the hair with bold strokes. Use the mixes on the palette and add burnt umber and burnt sienna. Finally, use the large fan brush to blend the work on the canvas, remembering to keep wiping it clean to avoid muddying the paints. It is worth noting that you may have to wait several hours for this stage, in order than the underpainting has time to dry sufficiently for the blending to work well.

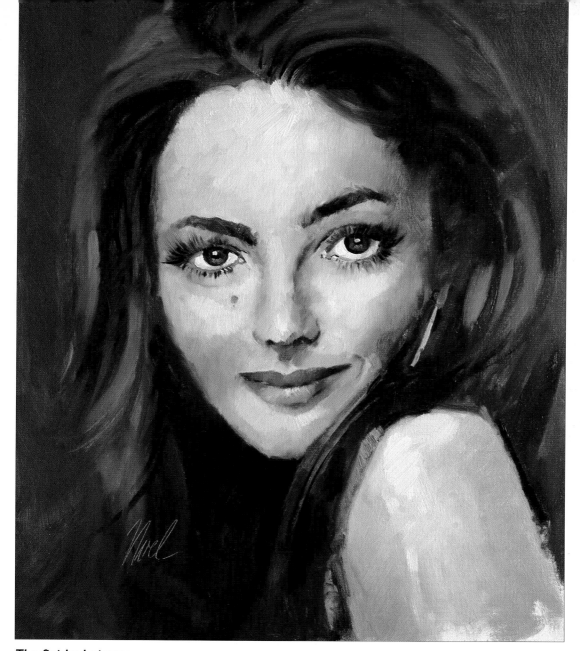

The finished picture

300 x 400mm (12 x 16in)

This finished picture and the self-portrait (right) show the difference between the skin tones of a young girl and an ancient artist. The finished textures on the self-portrait are the result of using flat bright brushes of different sizes and moving colour and tone with strong brushstrokes. This would make the flesh tones very ageing in the young girl's portrait, so blending is very important here.

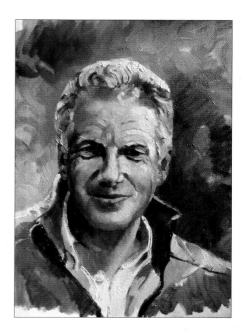

Self-portrait

300 x 400mm (12 x 16in)

My self-portrait was worked from a photograph. Normally you can paint a self image by using a mirror, but somehow I have never been able to do this without a huge struggle.

CHANGING PAINTINGS

GLAZING

If at any time you need to change the tonal structure of a picture, one way is to repaint that picture, but an instant way is to use glazes. Glazing and varnishing were once important techniques used in picture making. So important, in fact, that exhibitions held what was referred to as 'varnishing day'. The Royal Acadamy in London, for example, held this after the hanging had been completed for its summer exhibition. It was only then that it was considered that the artist could finish the work in its proper environment and light.

Colours created by glazing are stronger in depth and resonance than any colour created by mixing. The luminosity in Renaissance portraits, especially in skin tones, amply demonstrates this. Paintings can be completely changed by a wash to unify colour.

Glazing can also be useful for intensifying shadows over original colours or even heavy impasto, making an otherwise dull area more alive and interesting. Many coats can be applied to an oil painting when it is dry.

Oil glazes can be used over quick drying acrylics, alkyds or egg tempera The most effective technique is using the glazes over a white base, which allows the colours to be reflected back.

You will need

Canvas board, 800 x 500mm
 (31½ x 20in)
Flat size 2 brush
Clean dry cloth
Glaze medium

Colours

French ultramarine

Alizarin crimson

Lemon yellow

Why change?

- Glazing emphasises tones and improves colour balance.

- You can give a new look to an old painting by glazing large areas to create a fresh tonal image.

- Glaze yellow over tired areas and lighten a dull picture.

- Use a blue glaze over a painting that looks flat. Make sure that the glaze covers only the areas that you want to recede.

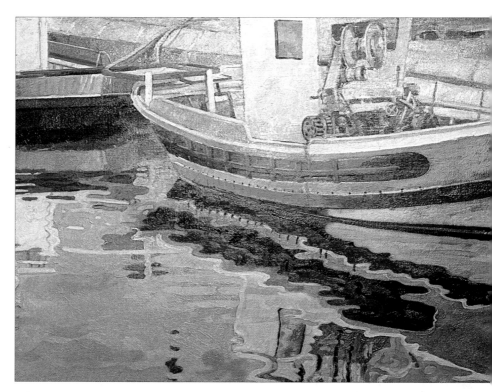

What is wrong with this picture? Well, nothing really, except it is a bit boring tonally, there is no centre of dramatic interest and the water area is slightly confusing to the eye. This can be remedied by using glazes. You could use a glazing medium, or colour can be thinned with turpentine or linseed oil, either together or on their own, to achieve the desired effect.

1. Using the flat brush, a mix of alizarin crimson and French ultramarine and a little glaze medium is brushed on to the bow of the boat when the painting is completely dry.

2. While the glaze is still wet, rub the colour off with a clean dry cloth. Notice how in a few seconds the painting has more life, depth and contrast. Whole areas can be dramatically changed tonally, or unrelated colours brought together by a common hue using this method.

Fishing Boats in the Harbour

800 x 500mm (31½ x 20in)

1½ Hours

The sea is now simplified with a glaze of French ultramarine, and a lemon yellow glaze has been applied to the boat, creating a feeling of sunlight. This is the essence of instantly changing a picture. All these changes have been made in only a few minutes, instead of having to repaint large areas with thick paint to create more tone and contrast.

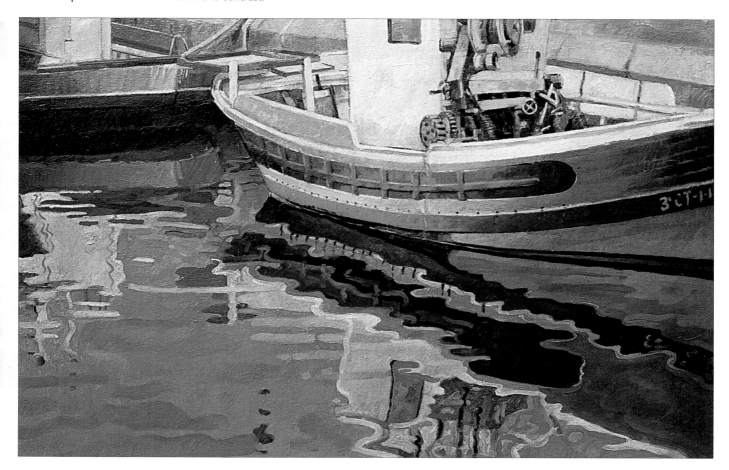

ALTERING TONES

After completion I felt that the tonal contrast of this still life was weak and decided to darken parts of the composition with a glazing medium mixed with blue and red paint for the background and foreground areas respectively. Once applied, I removed the glaze where necessary to create stronger tonal contrasts between the areas.

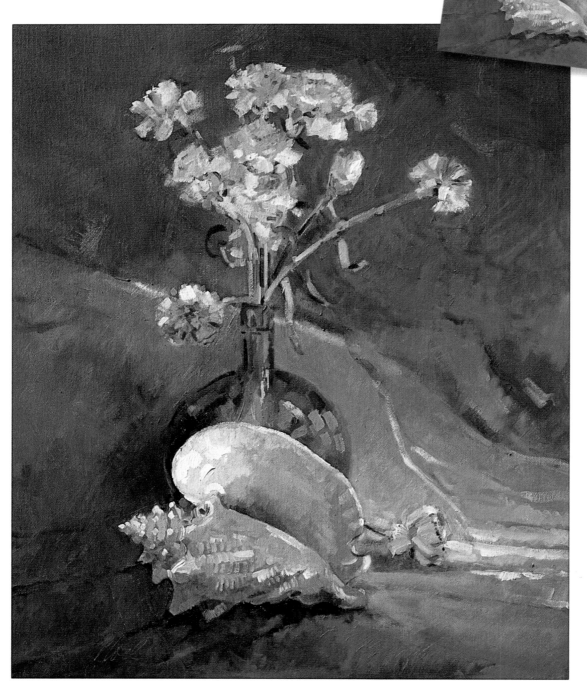

3½ Hours

Flowers and Shells
460 x 550mm
(18 x 21½in)

CHANGING BACKGROUNDS

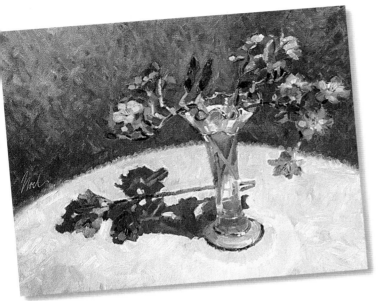

I kept looking at this picture and for months could not decide why I did not like it. The painting did not work together as a unit. Once the background tone and colour was changed, the composition was tranformed in minutes and the flowers given more value. If a painting does not work for you, remember that you can change it at any time, even years after completion. One of the great advantages of oil painting is that you can change paintings with relative ease and speed.

Fuchsias in a Glass Vase
410 x 330mm (16 x 13in)

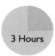

3 Hours

CHANGING YOUR STYLE

There are many exciting things to do when you have painted for some time. As experience is gained, your personal style will develop naturally as a result of the way you hold your brush and the colours you favour. Style is also influenced by the artists you admire and any instruction you receive; even reading this book may change your approach.

Sometimes it is an advantage to change your style intentionally by approaching your painting in a different way. For example, turn photographic references upside-down and copy them in this position. This will make the image unfamiliar, so you can concentrate on abstract shapes and tones.

In this demonstration, I show another way of changing your style. By using no preliminary drawing, and brushes made extra long by forcing their ends into metre-long bamboo canes, I have been made to concentrate on broad statements of picture making, rather than detail.

You will need

Canvas board, 920 x 650mm
 (36 x 25½in)
Brushes:
 Hog filbert size 8 (large)
 Short fat bright size 2 (small)
Bamboo canes
Plastic containers
Linseed oil

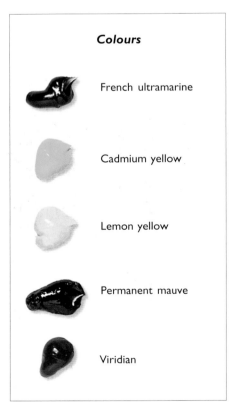

Colours

French ultramarine

Cadmium yellow

Lemon yellow

Permanent mauve

Viridian

1. Because of the difficulty in using a palette with such long brushes, I prepared a number of colour mixes copied from the area and put them in plastic containers. Make a start by blocking out the sky with absorbent paper dipped in a mix of French ultramarine and linseed oil.

2. Block out the main areas of the hillside, again using absorbent paper to apply the paint, this time cadmium yellow and lemon yellow with French ultramarine.

3. Extend the brushes by forcing their ends into the bamboo canes. Begin painting in the main details with your arm outstretched. This may seem peculiar at first, but you will soon get used to it. The actual mark of each brush stroke is one of controlled accident. Incidentally, this method of picture making was one favoured by my great hero Monet; who had most of his brushes specially manufactured with metre-long handles!

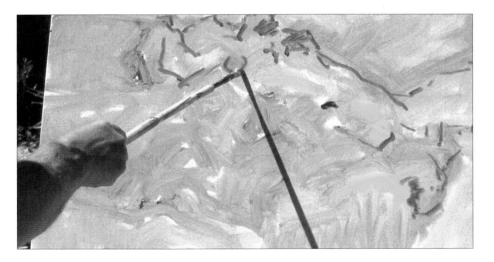

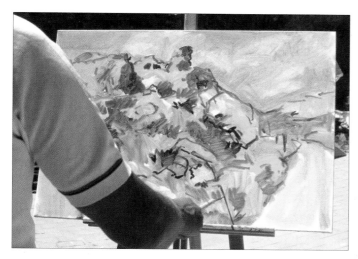

4. Remove the bamboo sticks and revert to painting from a palette. Concentrate on building up the painting as a whole, rather than thinking about detail.

5. For the final stages, I carried on using long brushes and stopped when I felt that overworking had started to compromise the freshness of the approach.

The finished painting

920 x 650mm (36 x 25½in)

4½ Hours

As you can see, using long brushes changed my style quite radically. Try something similar, even if it is a painting you have done before: you can compare the results and see which one you prefer.

Tip

Using extra-long brushes is one way of forcibly changing your style. Another is holding normal brushes at arm's length, but using your non-dominant hand (the left, if you are right-handed).

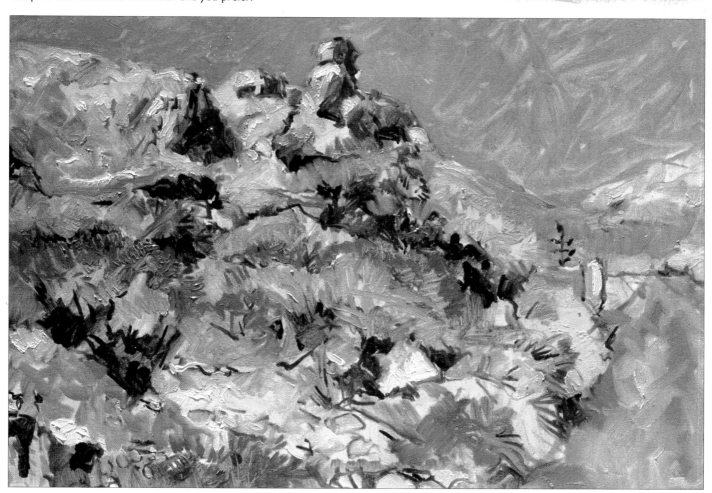

INDEX